HALF PRICE BOOKS
2481 Fairview Ave
Roseville, MN 55113
651-631-2626

11/12/12 05:12 PM
#00096/SDEA096/00002

CUSTOMER: 0000000000
SALE: 0000695199

1 7.99
 @7.99 56636228U
 1000000000056636228-The Quiet Hour
 0.00
 0.57
SHIP/HAND 8.56
TAX (7.125% on $7.99)
TOTAL

 PAYMENT TYPE 8.56
VISA (**8084/REF:39454220)
AUTH CODE:012155
 8.56
 $ 0.00
PAYMENT TOTAL $
CHANGE DUE

 THANK YOU!

 sign up for our mailing list
 BPA free and made of recycled content

 END OF TRANSACTION

THE QUIET HOURS

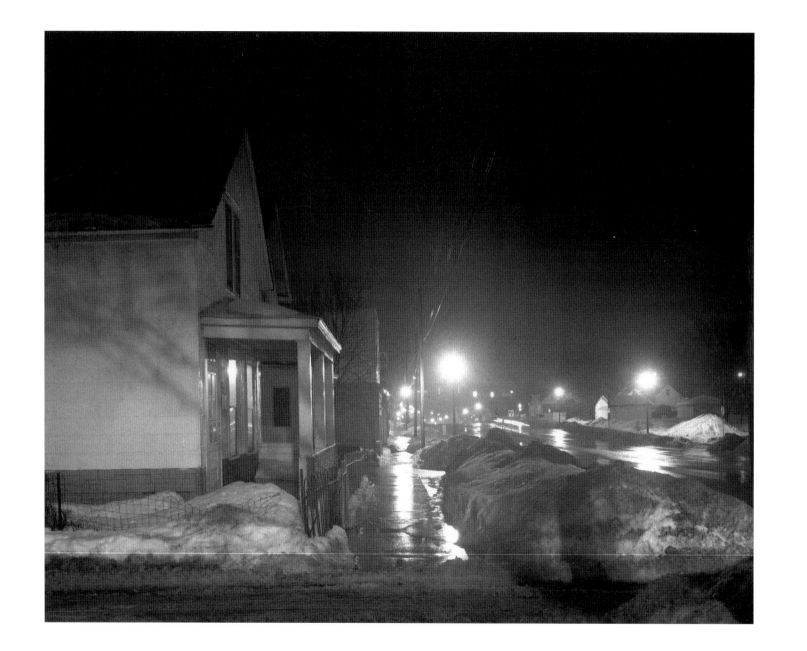

THE QUIET HOURS

CITY PHOTOGRAPHS

MIKE MELMAN

With an Essay by BILL HOLM

UNIVERSITY OF MINNESOTA PRESS *Minneapolis • London*

Library of Congress Cataloging-in-Publication Data

Melman, Mike.
The quiet hours : city photographs / Mike Melman, with an essay by Bill Holm.
p. cm.
ISBN 0-8166-4328-8 (HC)
1. Photography, artistic. 2. Architectural photography. I. Holm, Bill, 1943– II. Title.
TR654 .M453 2003
779'.4'092—dc21

2002156529

Published by the University of Minnesota Press
111 Third Avenue South, Suite 290
Minneapolis, MN 55401-2520
http://www.upress.umn.edu

Printed in Canada on acid-free paper

The University of Minnesota is an equal-opportunity educator and employer.

12 11 10 09 08 07 06 05 04 03
10 9 8 7 6 5 4 3 2 1

In short, I want to reach so far that people will say of my work:

he feels deeply, he feels tenderly—notwithstanding my so-called

roughness, perhaps even because of this.

—VINCENT VAN GOGH

CONTENTS

PREFACE

MY LOVE OF THE AMERICAN CITY BEGAN IN THE BRONX, WHERE I WAS BORN and grew up. My family lived in an apartment a few blocks from Yankee Stadium (I can still hear the roar of the crowd when someone hit a home run). I began to draw and paint the Bronx landscape at an early age, but my formal training started when I attended the High School of Music and Art across the river in Manhattan. That was followed by four years at the Cooper Union School of Art and Architecture in lower Manhattan and a bachelor of architecture degree from the University of California at Berkeley in 1962.

I worked in various architects' offices, but my heart still belonged to art. I continued to study art in the evenings. In 1967, as an experiment, I took an introductory photography course at The New School—and I had finally found my medium.

When I moved with my wife Lotte to Minneapolis in 1972, I began photographing the old buildings and streetscapes. I had never before seen anything like the flour mills and grain elevators. Some of them seemed unused or abandoned, and I knew I had to photograph them before they disappeared. At first I used a 35 mm hand-held Exakta and later a 2-1/4 inch square Mamiya, which is still my workhorse. I tried color but kept returning to black and white.

American cities change at a frightening speed, usually with little regard for the past. Minneapolis lost its historic gateway district, including the superb Metropolitan Building, during the urban renewal craze in the 1960s. It saddens me to think that some of my older photographs may be the only visual record of buildings and streetscapes that no longer exist and would otherwise be forgotten. Certainly they deserved a better fate. With foresight, most of these fine old buildings could have been integrated into the new downtown fabric.

These photographs are not my work alone. Many people over a lifetime have helped make them possible: Edward Hopper, Charles Burchfield, Walker Evans, Rembrandt, Eugene Atget, Frank Meadow Sutcliffe, Mike Lynch, Wayne Gudmundson, and Alfred Stieglitz are all artists whose work illuminated my path. My wife Lotte, without complaint, endured countless interrupted nights for the sake of my pre-dawn excursions. Bill Holm lent his wonderful literary talents to this project. Todd Orjala at the University of Minnesota Press initiated this book idea and persevered through five years of ups and downs during its development. My parents Louis and Gertrude, the children of immigrants, didn't understand much about art but helped me in every way they could. And, finally, I must thank my teachers from the New York City public schools, who gave encouragement to this shy, artistic boy back in the Bronx a long time ago.

MIKE MELMAN
Minneapolis, 2003

BILL HOLM

CITIES OF SHADOW AND LIGHT

YOU NOW HOLD IN YOUR HANDS SEVENTY BRILLIANTLY MADE IMAGES. With the exception of a few antique interiors, these are city images: stone and iron bridges, railroad yards, grain elevators, warehouses, factories, abandoned relics ready for the wrecking ball. They are taken mostly in half-light and bad weather, those early hours when the feeble winter sun of Minnesota can hardly squeeze its way up into the heavy overcast sky. The strongest light floods into the oversized windows of deserted buildings, ghosts of light come into empty bare rooms. The businesses in these pictures (taken mostly in the 1990s) are ghosts, too, from the 1920s and 1930s—a shoe repair shop, a confectionery, an old lunch counter, a violin maker, a kosher butcher. They have tin ceilings, glass-doored wood cabinets, and single owners, usually old men with immigrant names. Where are The Gap, Starbucks, Borders, Target, the mall, the lights, and the shoppers? Not here. Nary a human in any of these images.

[1

Think of all the clichés about America that float like heavy marshmallows through our national consciousness. We are a young country, still unburdened by the weight of history that so darkens Europe. We are optimists believing tomorrow always will be a better day. We can pick ourselves up by our bootstraps and make it new. We live in a place of unbounded natural beauty—waves of amber grain from sea to shining sea—and though we have left the farm for the corrupt and ugly city, the best part of us is a spiritual Jeffersonian yeoman farmer, ready to do battle with heavy industry to restore our pristine wilderness, that mythic Eden that only a few generations ago existed untarnished by history and human meddling. In this America the sea shines bright all day long. It is without shadows.

The pastoral myth has lasted a long time in America, maybe longest in the Midwest—in the Minnesota that is the scene of these images. Our postcards and calendar photographs are full of loons, pine-girdled lakes, the Split Rock lighthouse, moose, red barns, and cornfields all flooded with light—maybe even a red-orange sundown over a farm. But we are not farmers any more. The past century of American life hardly touches these tourist photographs.

Real artists, on the other hand, are interested not in commercial marketing and promotion but in opening the human eye to the unexpected truth and beauty of reality. Mike Melman is such an artist, and these seventy images intend to show you a world you had not imagined to be so full of beauty. He does not, however, mean to cheer you up. These pictures risk invoking two small adjectives that strike a chilly fear into the American sensibility: old and sad.

Mike Melman was born in 1939 in the Bronx. He has been a Minnesotan for many years, but it is quite clear from these pictures that his childhood gave him a city eye and an affection for the underground, hidden life of cities, the places no one thinks to look at—unless your eye is alert to what can be seen. Cities carry their history on their back like turtles. It is mostly invisible to casual shoppers and commuters, but turn down the wrong street, find yourself lost in the railroad yard, or stop to peer in the dusty windows of vacant buildings, and you see not 2003 but 1950 or 1930 or 1910. If cities age and carry their used parts inside them, then we too must age. America, land of youth and opportunity, never likes to be reminded of its interior relics. That fear of visible age has cost us some of our best buildings, as any architect will tell you.

Melman sees his birth year, 1939, as a kind of watershed in the lives of American cities and their architecture. Our industrial substructure was in place, already well used, the tracks laid, the warehouses full of goods, the rivers bridged, the heavy stone office buildings bottomed by small ground-floor storefronts, the character and feel of neighborhoods intact. The massive suburban retreat accelerated ferociously after the war, bringing with it the desertion of central cities and the rise of the big box with attached parking lot. The Twin Cities of Minnesota were still compact; compared to New York, these were only big overgrown towns, but by Midwest standards they were real cities. We've learned skepticism when modern politicians tell us after some national catastrophe that "everything is now changed," but a real case can be made for a significant sea change in American life after 1939. The old heart, lungs, and bones of cities found themselves gradually vacated, neglected, melancholy ghosts of their proud days.

So here are pictures of old places that remind us of our own age, but they are sad too in that what was beautiful and majestic in these buildings has been replaced by a species of soulless utilitarianism. Now we buy our musical instruments from the electronics aisle at the XYZ Mart, not from an old craftsman with thin varnish-stained fingers working behind a glass storefront criss-crossed with spider webs on the ground floor of a stone building with Gothic arches at the entrance.

There's a danger of nostalgia when looking at these seventy haunting pictures, but we should, as the artist did, beware falling into it. These are *not* pictures of the good old days or of some lost Shangri-la of refined taste and quality buildings. These are practical everyday places, used places, streets where ordinary people lived and grain elevators, railroad yards, and factories where they carried their lunch buckets to work. What these photographs give us is insight into the pulsing real life of cities where we had not previously thought to look for beauty.

These pictures, of course, have ancestors in both American art and literature, and they have distinguished relatives. Neither visual artists nor poets much noticed the industrial revolution or the growth of cities in the nineteenth century. Thoreau hears the train noise going by Walden Pond; it disturbs the solitude of his flute practice, and he doesn't much like it. A reader would imagine after a browse through the poems of William Cullen Bryant, Henry Wadsworth Longfellow, John Greenleaf Whittier, James Russell Lowell, et al. (or through the then still unpublished work of Emily Dickinson) that no American lived out-side quaint rural villages or had ever ridden a train or worked in a factory. The first literary rebel (in this as in so many other ways) was Walt Whitman, an unabashed city man, "lover

of populous pavements," a "dweller in Manahatta my city." He cadged rides with his friends the ferry drivers in order to enjoy

> The blab of the pave, tires of carts, sluff of boot soles, talk of the promenaders,
> The heavy omnibus, the driver with his interrogating thumb, the clank of the shod horses
> on the granite floor.
>
> <div align="right">("Song of Myself," lines 154–55)</div>

In "Crossing Brooklyn Ferry" Whitman writes what is likely the first and still the greatest American poem that celebrates an ecstatic urban experience.

Not long after the turn of the century, Carl Sandburg joined Whitman as a maker of art growing from city life, though now not New York but Chicago (*Chicago Poems,* 1916). Sandburg, like Melman, finds beauty in unlikely urban places:

Nocturne in a Deserted Brickyard

Stuff of the moon
Runs on the lapping sand
Out to the longest shadows.
Under the curving willows,
And round the creep of the wave line,
Fluxions of yellow and dusk on the waters
Make a wide dreaming pansy of an old pond in the night.

Again like Melman, Sandburg finds more beauty in half-dark than in full sun. This image could be a Melman photograph:

Window

Night from a railroad car window
Is a great, dark, soft thing
Broken across with slashes of light.

In 1883, twenty-seven years after Whitman published "Crossing Brooklyn Ferry," John Roebling's new bridge put the ferry out of business. This magnificent cathedral of a bridge with its soaring Gothic arches and its wind harp of steel strings began to create its own myth: the triumph of the city over the countryside, the consummate achievement of technology, the bridging not just of the East River but of the whole continent, and the new hemisphere itself connected at last to the old world. The bridge was painted, photographed, sung, and celebrated mightily. Hart Crane, a young poet from Ohio, decided in 1923 to make it the central metaphor of his try at the great American epic. He sings in *The Bridge*:

O sleepless as the river under thee,
Vaulting the sea, the prairie's dreaming sod,
Unto us lowliest sometime sweep, descend
And of the curve ship lend a myth to God.

The completed poem, first published in an elegant hand-set edition in Paris in February 1930 by Black Sun Press, was adorned with the first published photographs by Crane's good

friend, the young photographer Walker Evans. Here we encounter something like Melman's real artistic grandfather beginning his career with black and white photographs of the steel underbelly of the Brooklyn Bridge, coal barges and a tugboat seen from the top and the harp of strings and Gothic towers seen from the promenade—stark black and white forms, bare steel and stone in a soft gray cloudy light. Alan Trachtenberg describes Evans's photographs in *Brooklyn Bridge: Fact and Symbol*: "They are not merely recognitions of the bridge, but constructive visions, unexpected organizations of objects in space: not simply representations of Brooklyn Bridge, but also of the act of seeing, of the photographic discovery that form follows point of view. . . . Here the bridge is seen freshly, not merely looked at; it emerges . . . as the vision of a specific eye, as someone's palpable experience."[1] The same can be said of Mike Melman's seventy images, mostly of the city, in this book, ten of them of old bridges. Though Minnesota bridges may lack the dramatic grandeur of the Brooklyn Bridge, they cross the Mississippi, the continental aorta that dwarfs even the East River in metaphoric power.

Alfred Stieglitz was spiritual mentor to both Crane and Evans in two significant ways, first in his defense of photography as an autonomous art: "Unless photography has its own possibilities of expression, separate from those of the other arts, it is merely a process, not an art."[2] Stieglitz devoted his energies and his famous 291 Gallery to making both an independent American and an urban art, in photography, painting, and ideas. He took New York as one subject, and his 1903 photograph of the Flatiron building in falling snow is the direct ancestor of Melman's photographs of Minnesota snow on bridges, railroad yards, warehouses, and deserted streets. Stieglitz insisted on resisting the tendency to romanticize unpoetic subjects, but, says Robert Hughes about the Flatiron picture, "The stronger option

was to depict [unpoetic subjects] head-on, with a detached eye (behind which a deeper romanticism could still beat, concealed), in all their flatness, hardness and apparent banality."[3] You can feel that deeper concealed romanticism in these seventy images by Melman.

But the great artistic godfather of these eerily wonderful images is certainly Edward Hopper—not a photographer but a painter, most famously of *Nighthawks*. Like Melman, Hopper showed little interest in conventional "beauty." In an often told and revealing story, Hopper's wife Jo, also a painter, dragged him with her in 1925 to New Mexico, at that time, following Georgia O'Keeffe's migration, probably the most painted and paintable landscape in America. Oh, those weirdly shaped mountains, brilliantly colored deserts, clear sharp light! Hopper was miserable. There was nothing for him to paint—it was all too beautiful. After weeks without picking up a brush, Hopper disappeared one afternoon, taking his watercolors with him. Jo searched and finally found him in a grimy railroad yard, happily painting an old locomotive. Mike Melman would be in the same railroad yard with his camera at 3 or 4 in the morning, having patiently waited for gray drizzle or the first dusting of snow over Santa Fe. Hopper once confessed to loving the light in Paris: "The shadows were luminous—more reflected light. Even under bridges there was a certain luminosity. Maybe it's because the clouds were lower there, just over the housetop. I've always been interested in light."[4]

Hopper would probably have liked the heavy winter light in Minnesota, and he would certainly have loved the interior light in the Grain Exchange or the Veterans' Home or Samuelson's Confectionery or the Ford Steam Plant. Lloyd Goodrich describes the shock of Hopper's early painting: "We were not used to seeing such commonplace, and to some of us ugly, material used in art. . . . Hopper was painting an honest portrait of an American

town, with all its native character, its familiar uglinesses and beauties. On the whole his attitude was affirmative. He preferred American architecture in its unashamed provincial phrases, growing out of the character of the people."[5] And so does Mike Melman. How Hopper would have loved Knauer's Meat Market or Jim's Hamburgers. Hopper, like Melman, was a New Yorker with a city eye, and the city "was the center of much of his work . . . the huge complex of steel, stone, concrete, brick, asphalt and glass . . . its heavy masses of masonry and concrete; the individual forms of buildings, their surfaces and ornamentation, the effect of light on them; the omnipresence of glass, and the phenomenon of life seen through windows; night on the city with its multitude of lights and its ominous shadows."[6]

Finally, like Hopper, Melman is an early riser who prefers empty streets before anyone is up. It is pleasant to imagine Hopper with his paints; Evans, Stieglitz, and Melman with their cameras; and probably Crane, Sandburg, and Whitman for charm and metaphor standing next to William Wordsworth on a Westminster bridge on September 3, 1802, watching London as

> The river glideth at his own sweet will;
> Dear God! The very houses seem asleep;
> And all that mighty heart is lying still.

These photographs take us a long way toward an understanding of that mighty heart of a city—and indeed of Minnesota and all of the United States. These are very American pictures in their stubbornness, their integrity, and their dogged affection for the working-class life buried inside them. It's hard to think of them without metaphors arising in the mind,

and that is a sign of their quality and effect. My favorites are the haunted stairways that disappear into the space at the top of the picture, stairways without feet to weigh them down, stairways flooded with light that seems to come from some other world that the camera has magically discovered. I commend to you the parsonage, the commandant's house, the steam plant, the brewery, and, eeriest of all, the school for the deaf. These images made from light with a camera do the same work as poems in this world: they make us glad that we are alive to see them.

NOTES

1. Alan Trachtenberg, *Brooklyn Bridge: Fact and Symbol* (Chicago: University of Chicago Press, 1965).

2. Robert Hughes, *American Visions: The Epic History of Art in America* (New York: Alfred A. Knopf, 1997), 351.

3. Ibid., 371.

4. Lloyd Goodrich, *Edward Hopper* (New York: Harry N. Abrams, 1976), 13.

5. Ibid., 36.

6. Ibid., 68.

THE QUIET HOURS

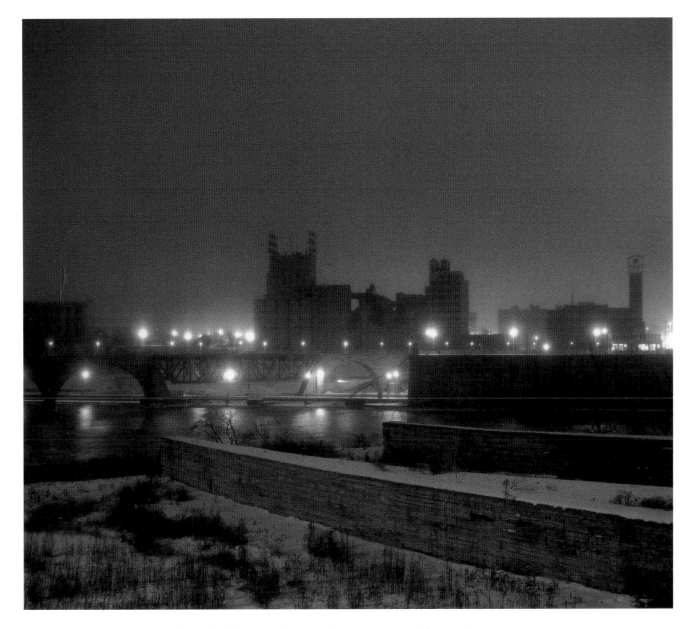

VIEW OF MILLING DISTRICT AND MISSISSIPPI RIVER, MINNEAPOLIS, 1995

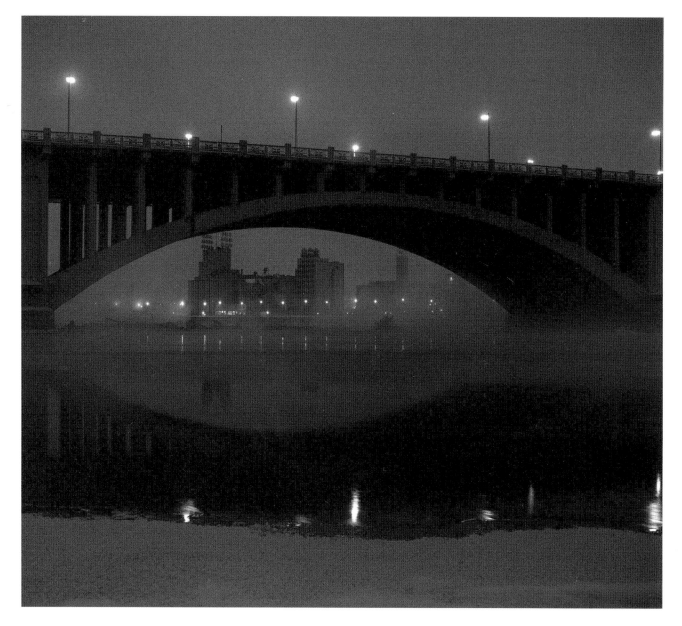

ST. ANTHONY FALLS AND THIRD AVENUE BRIDGE, MINNEAPOLIS, 1994

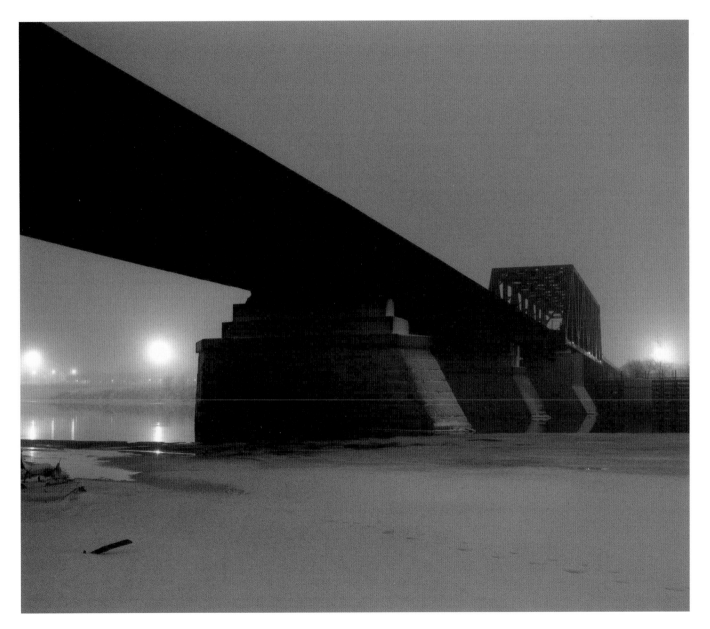

SOO LINE RAILROAD BRIDGE ACROSS THE MISSISSIPPI RIVER, NORTHEAST MINNEAPOLIS, 1996 [15

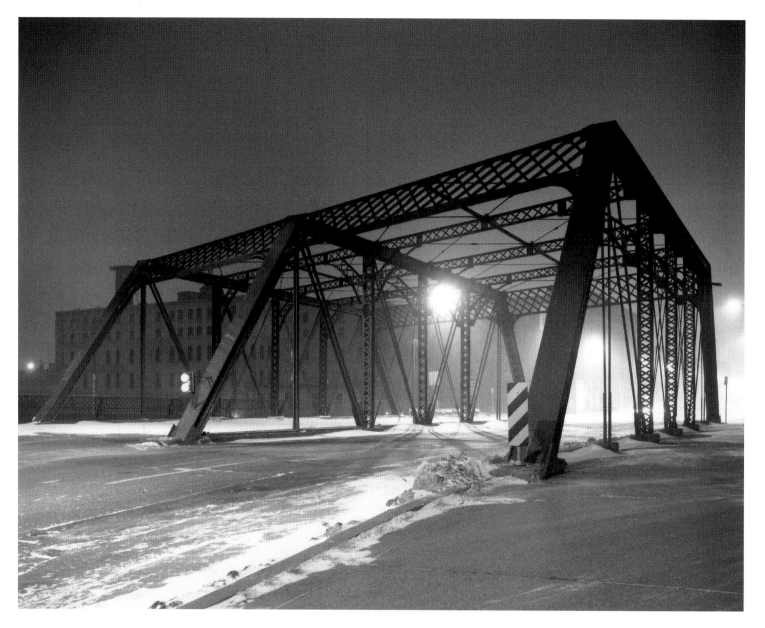

RAILROAD BRIDGE, WASHINGTON AVENUE NORTH, MINNEAPOLIS, 1992

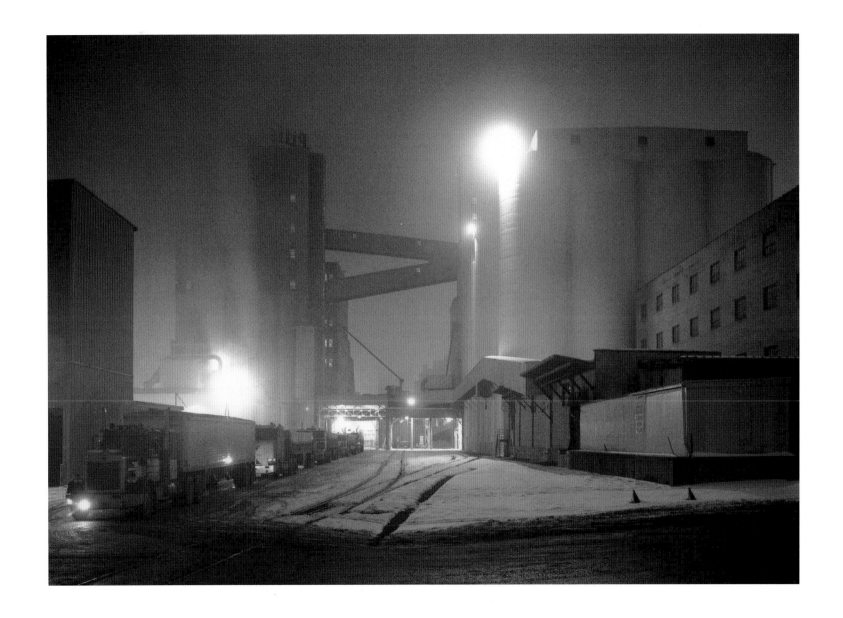

PILLSBURY "A" MILL, MINNEAPOLIS, 1991

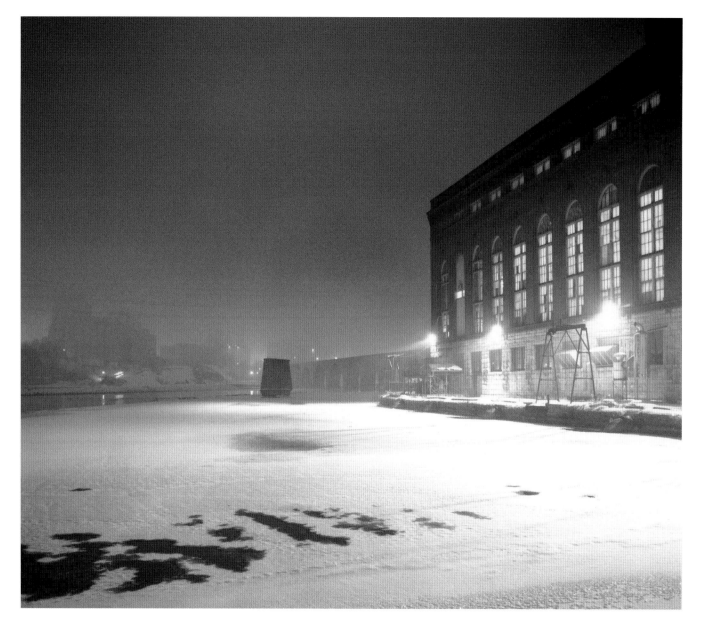

SOUTHEAST STEAM PLANT AND STONE ARCH BRIDGE, MINNEAPOLIS, 1991

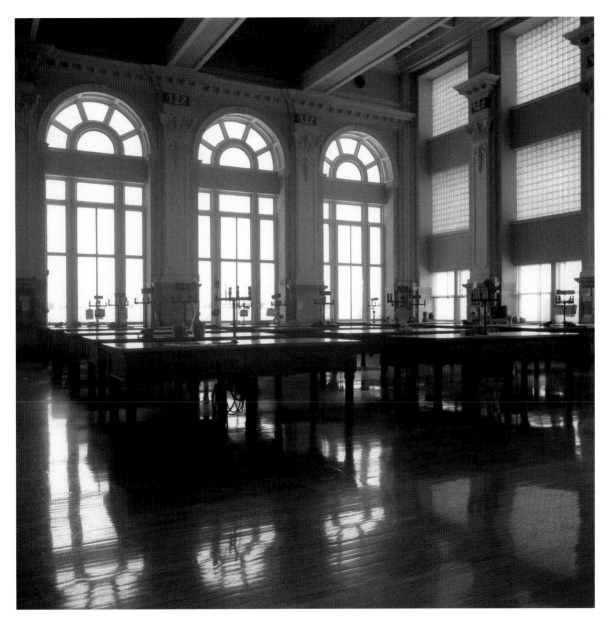

FLOOR OF MINNEAPOLIS GRAIN EXCHANGE, SOUTH FOURTH STREET, MINNEAPOLIS, 1992

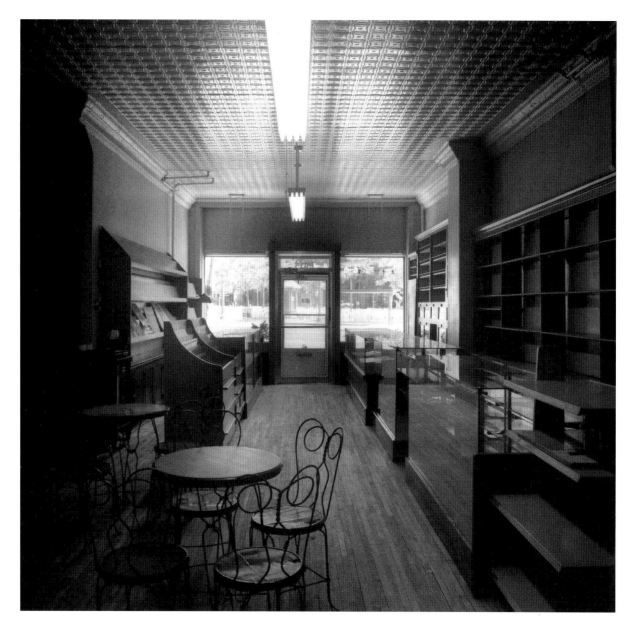

SAMUELSON'S CONFECTIONERY, SEVEN CORNERS, MINNEAPOLIS, 1995

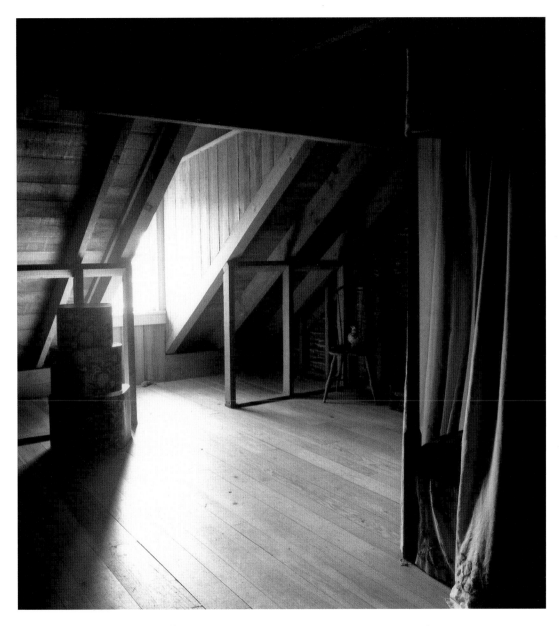

BEDROOM, COMMANDANT'S HOUSE, HISTORIC FORT SNELLING, 1996

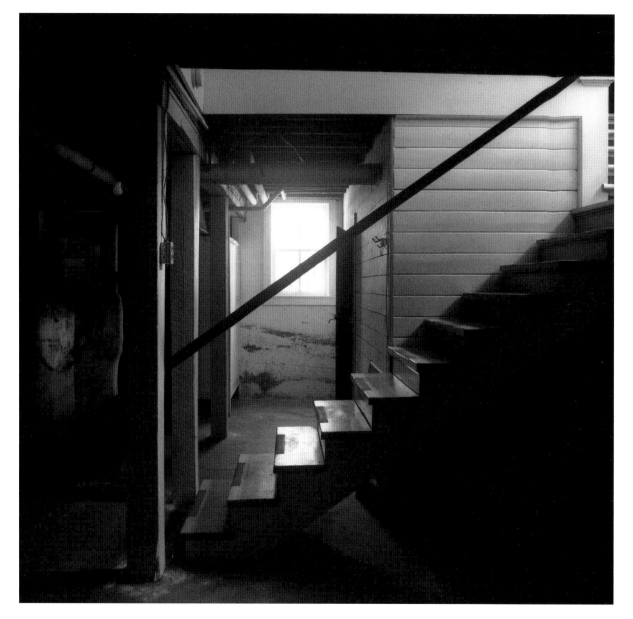

PARSONAGE, FIRST CONGREGATIONAL CHURCH OF FARIBAULT, FARIBAULT, MINNESOTA, 1995

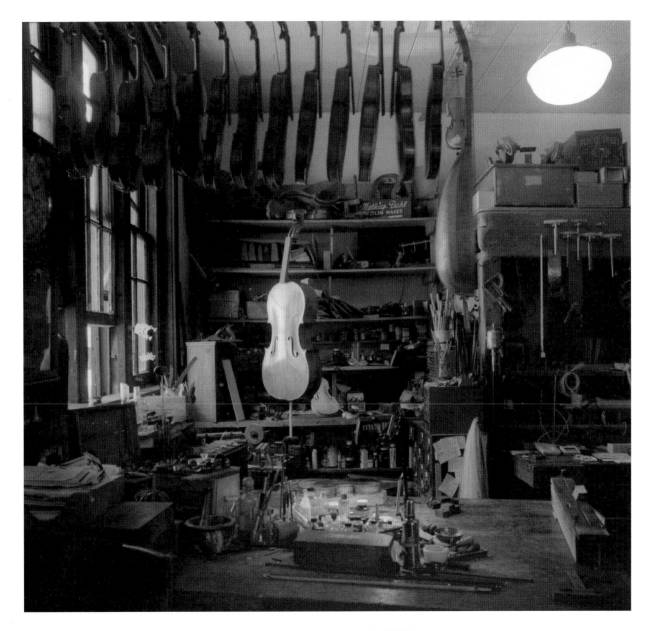

DAHL VIOLIN SHOP, SOUTH TENTH STREET, MINNEAPOLIS, 2000

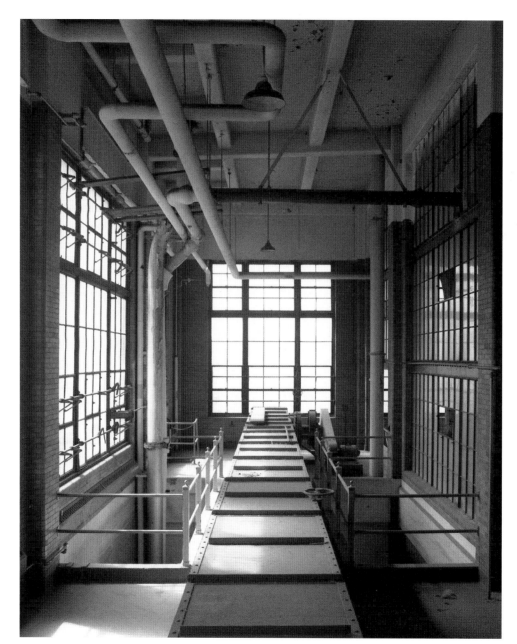

STEAM PLANT,
FORD MOTOR
COMPANY,
ST. PAUL, 1992

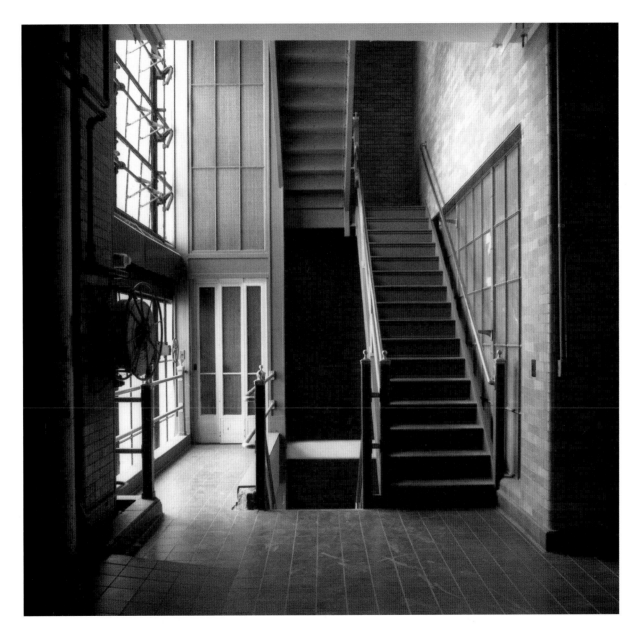

STEAM PLANT, FORD MOTOR COMPANY, ST. PAUL, 1992

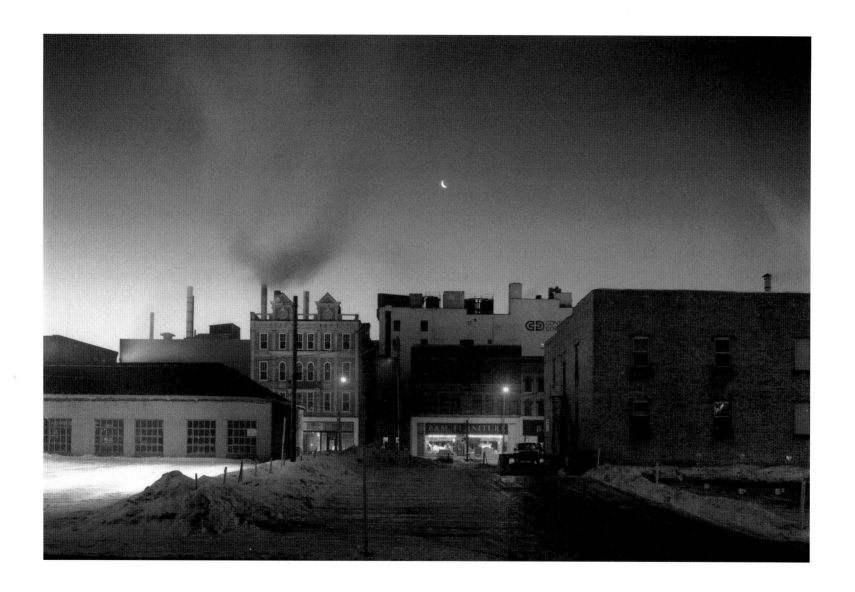

EAST SEVENTH STREET BETWEEN WALL AND WACOUTA STREETS, ST. PAUL, 2001

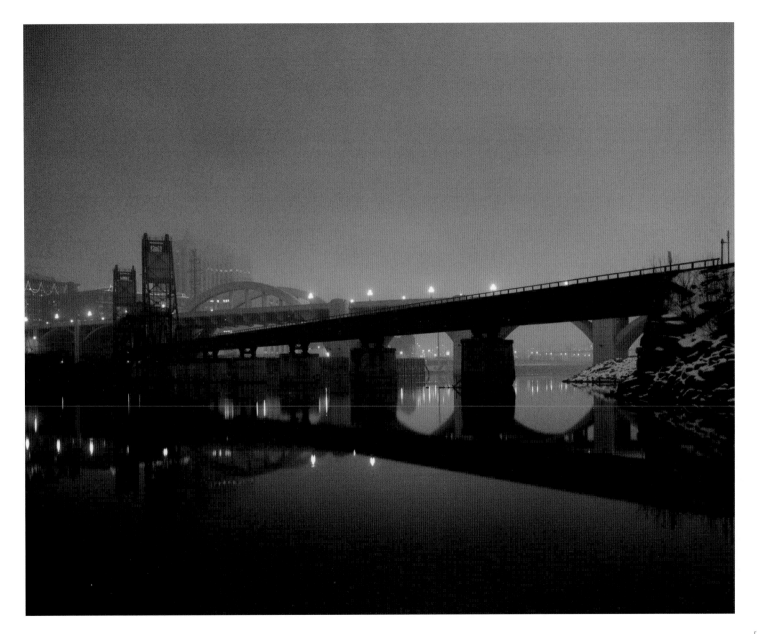

RAILROAD LIFT BRIDGE AND ROBERT STREET BRIDGE, ST. PAUL, 1995

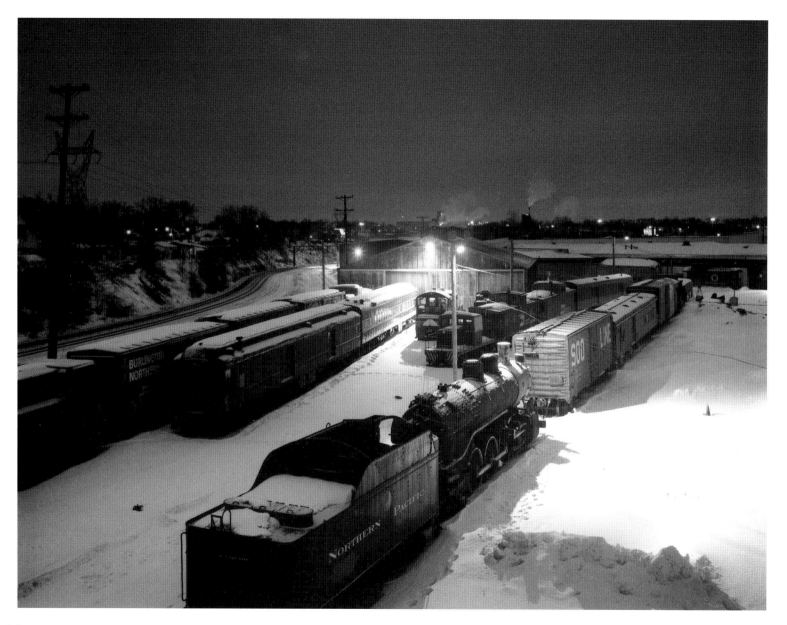

JACKSON STREET ROUNDHOUSE, MINNESOTA TRANSPORTATION MUSEUM, ST. PAUL, 1997

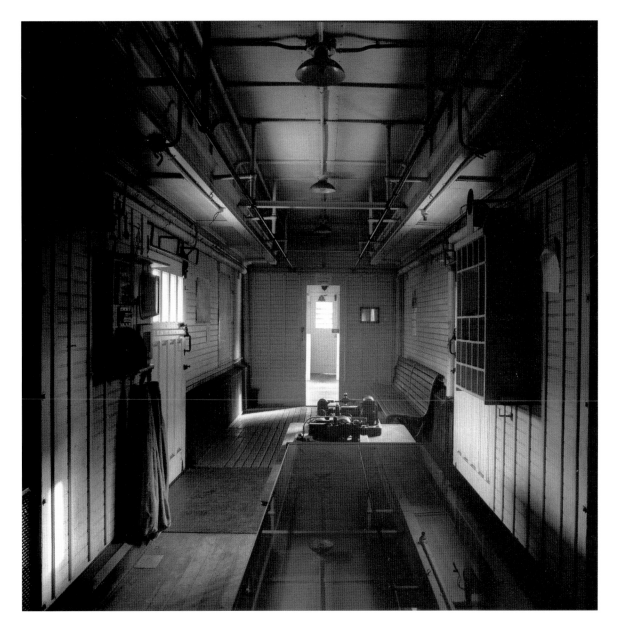

NORTHERN PACIFIC CAR NO. 110, JACKSON STREET ROUNDHOUSE, MINNESOTA TRANSPORTATION
MUSEUM, ST. PAUL, 1997

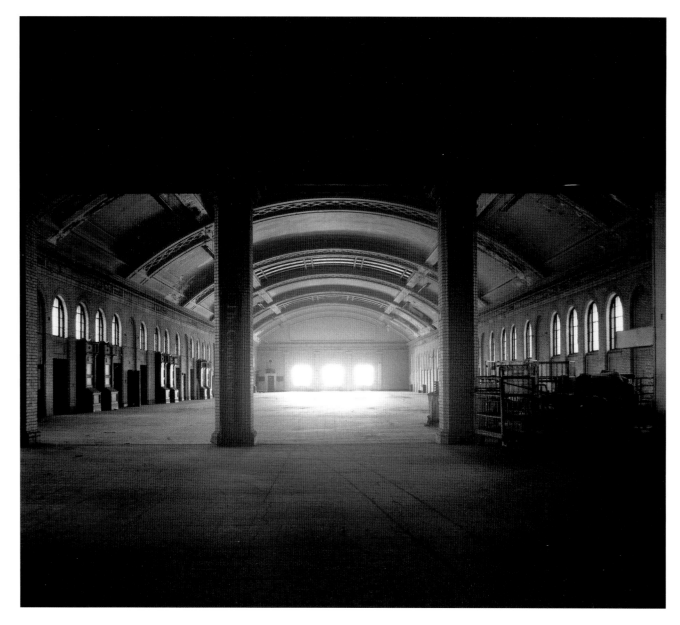

CONCOURSE, UNION STATION, ST. PAUL, 1992

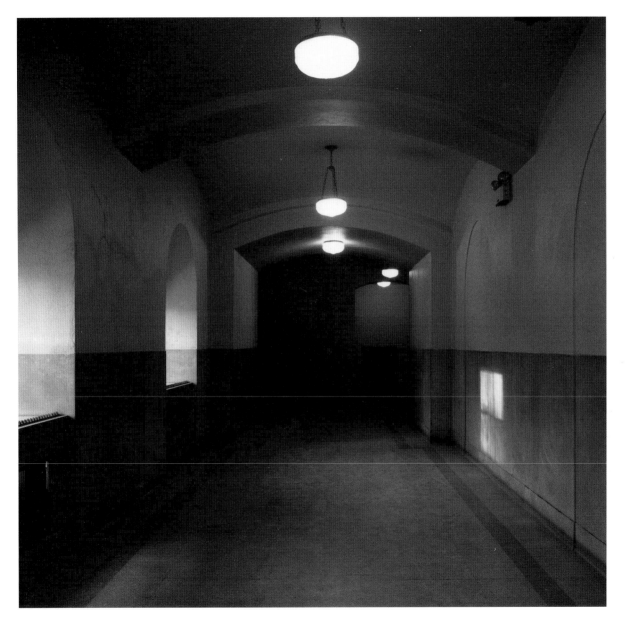

SIBLEY STREET ENTRANCE, UNION STATION, ST. PAUL, 1992

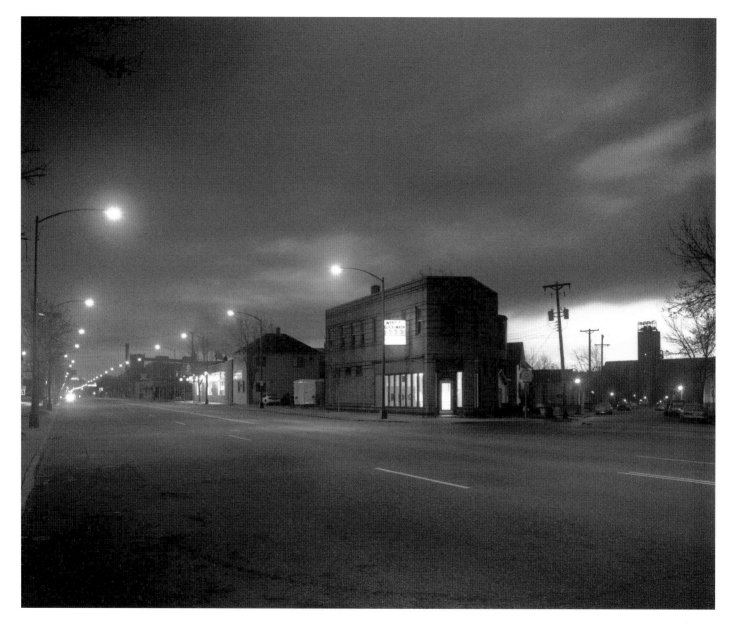

WEST SEVENTH QUICK WASH, WEST SEVENTH STREET AND WATSON AVENUE, ST. PAUL, 1999

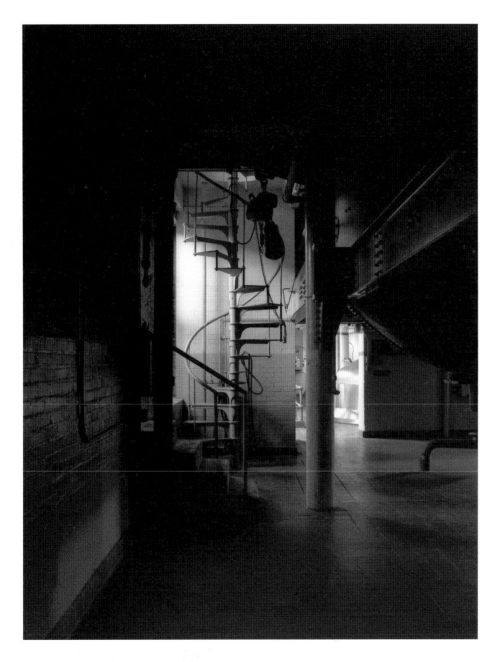

SPIRAL STAIR,
SCHMIDT BREWERY,
WEST SEVENTH STREET,
ST. PAUL, 1994 [33

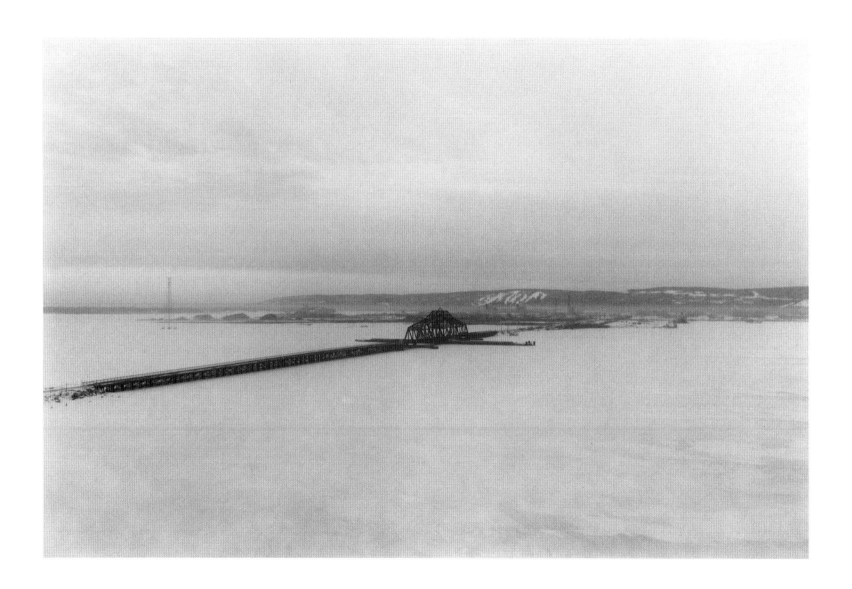

DULUTH AND ST. LOUIS BAY FROM THE ARROWHEAD BRIDGE, DULUTH, 1988

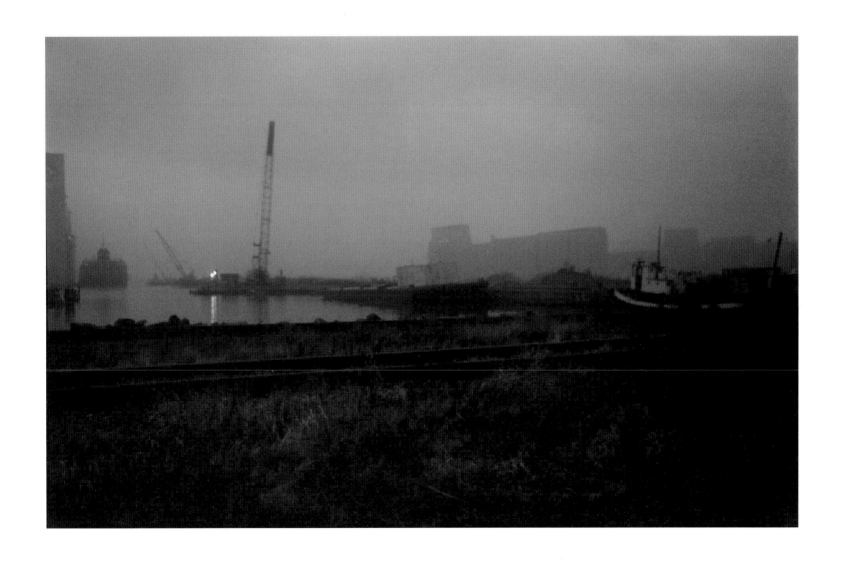

DULUTH HARBOR, 1988

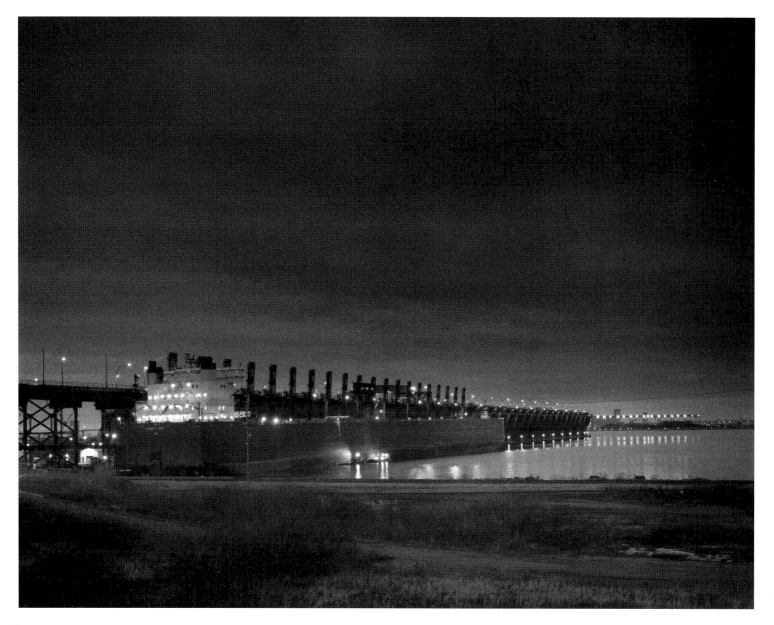

EDWIN H. COTY, ORE DOCKS, DULUTH, 1989

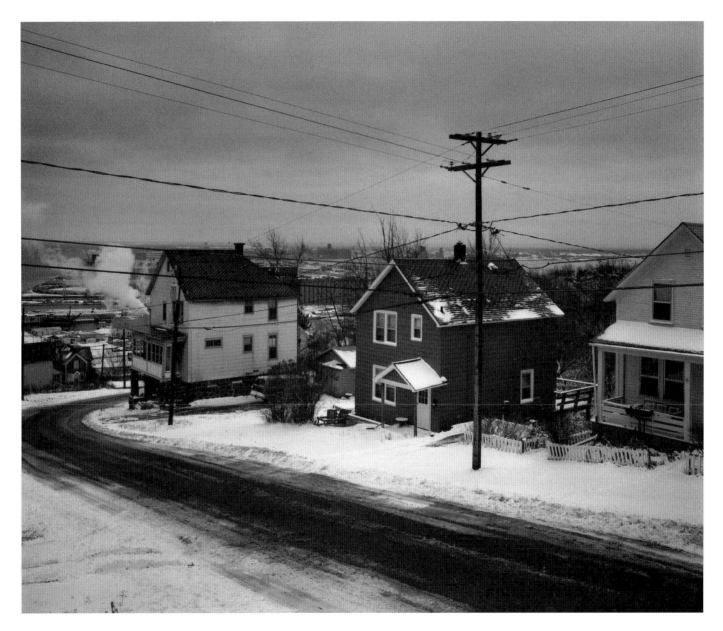

WEST DULUTH, 1990

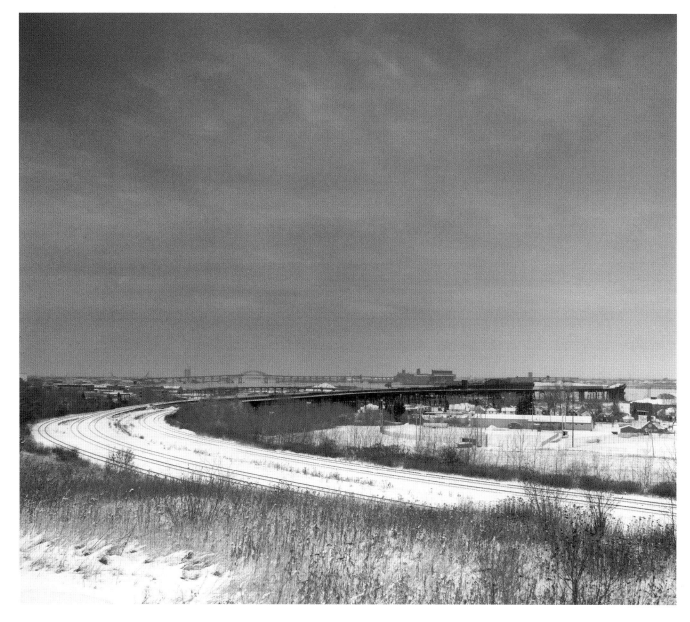

TRACKS OF THE DULUTH, MISSABE AND IRON RANGE RAILWAY AND ORE DOCKS, DULUTH, 1990

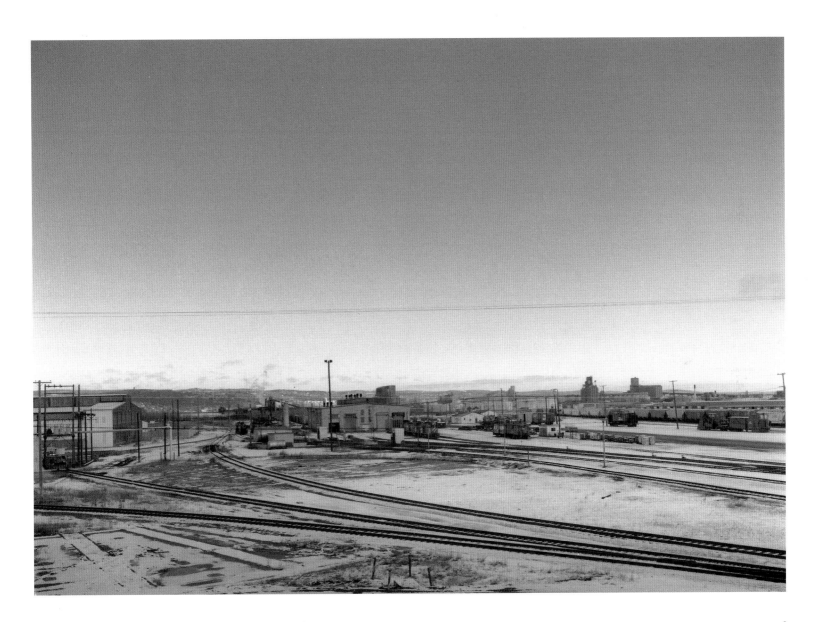

RAILROAD YARDS, SUPERIOR, WISCONSIN, 1990

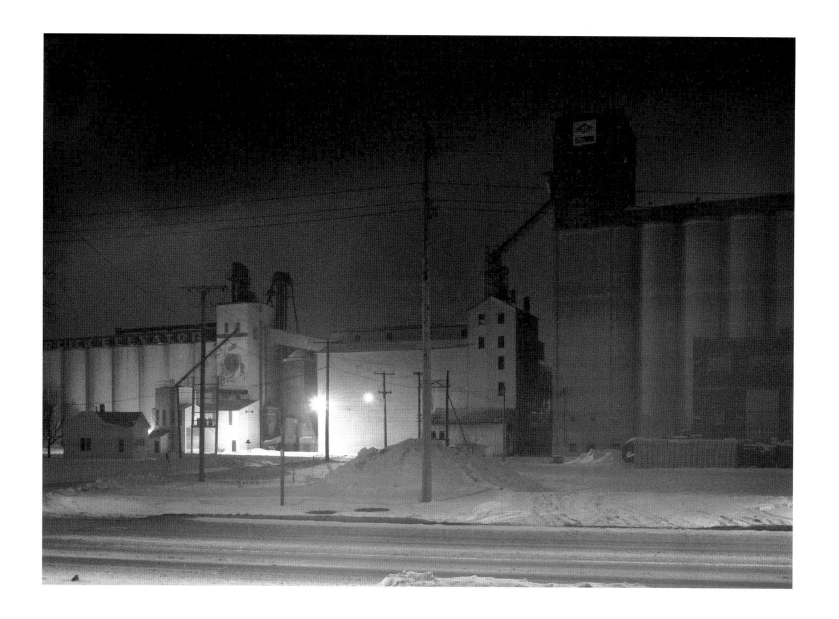

NEW ULM, MINNESOTA, 1994

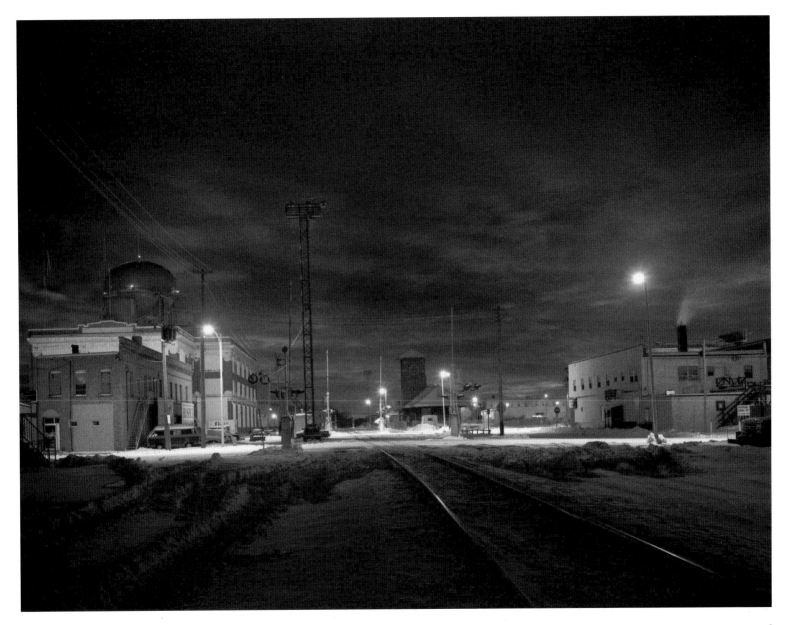

FARGO, NORTH DAKOTA, 1995

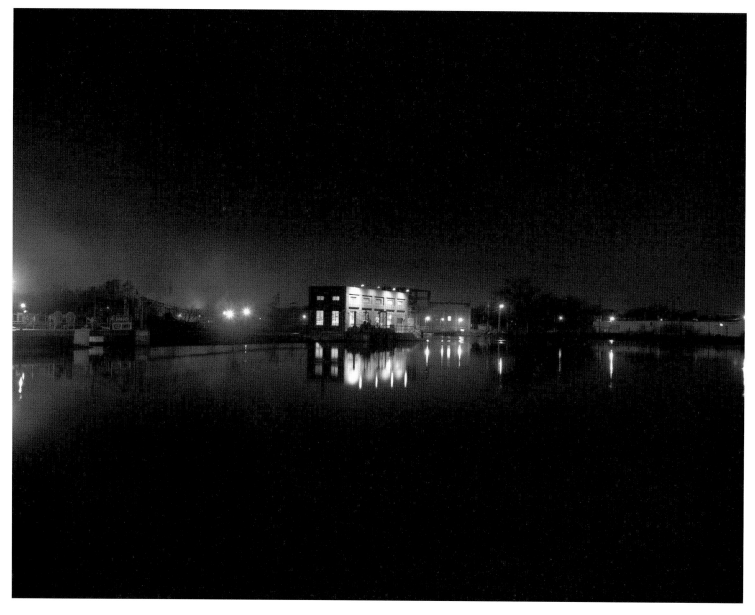

MINNESOTA POWER HYDROELECTRIC STATION, LITTLE FALLS, MINNESOTA, 1998

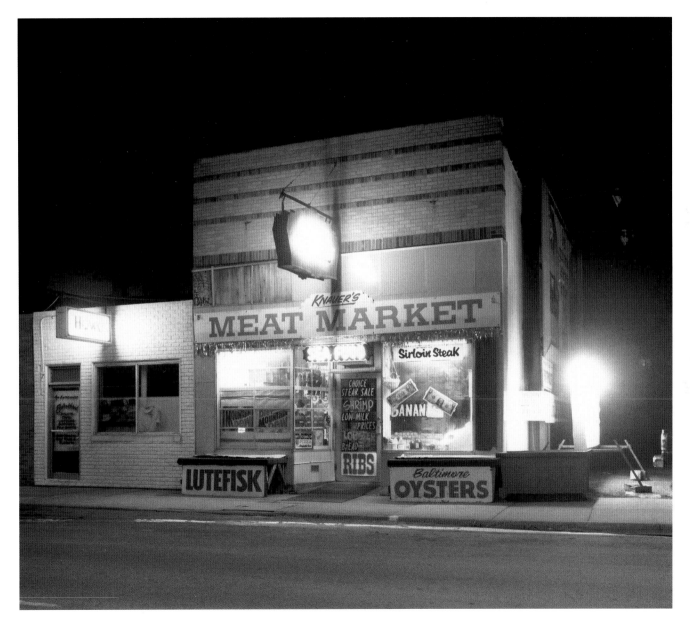

KNAUER'S MEAT MARKET, MAIN STREET, AUSTIN, MINNESOTA, 1996

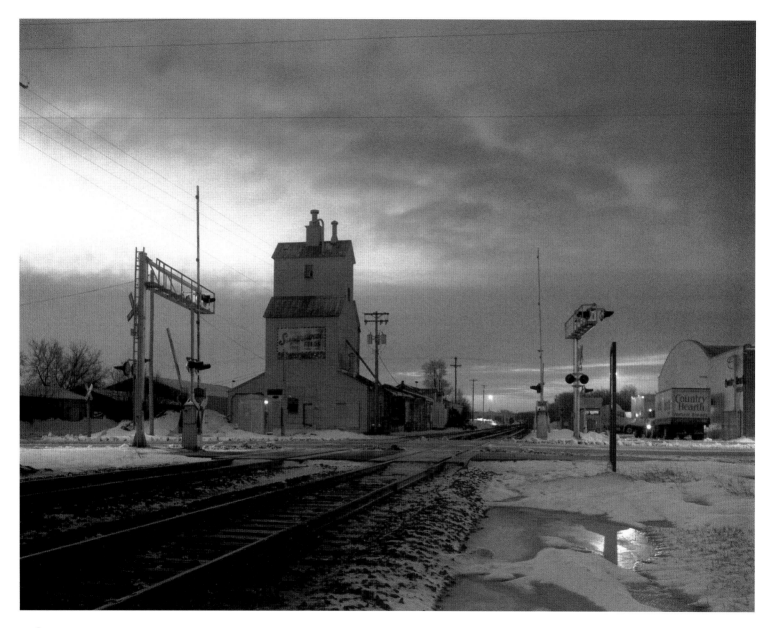

SUPERSWEET FEEDS ELEVATOR, ST. CLOUD, MINNESOTA, 1997

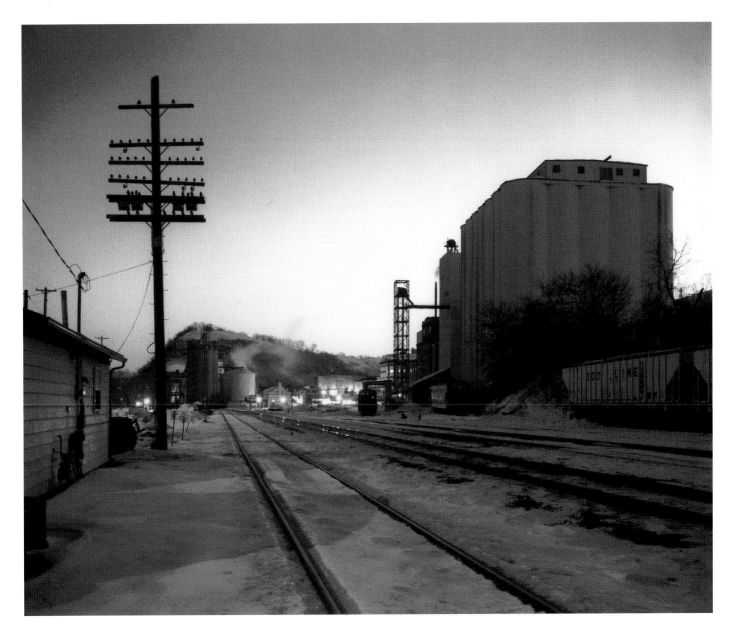

BARN BLUFF, RED WING, MINNESOTA, 1993

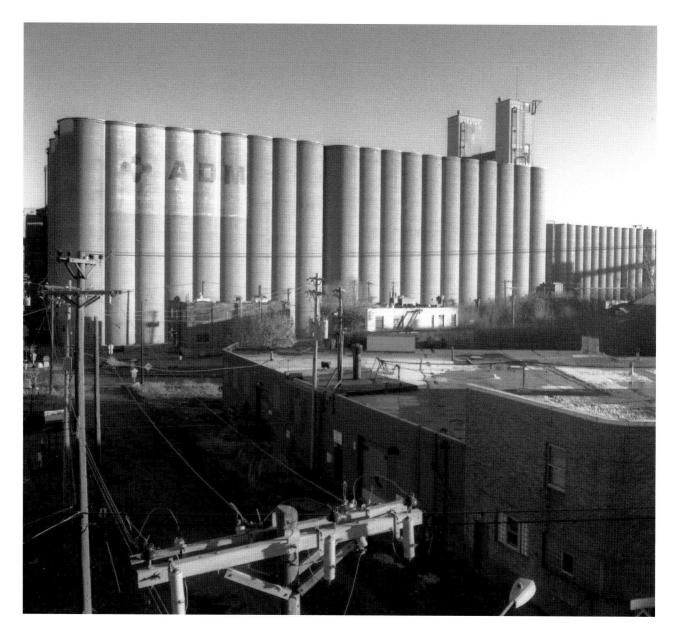

A.D.M. ELEVATOR, TWENTY-NINTH AVENUE SOUTHEAST, MINNEAPOLIS, 2002

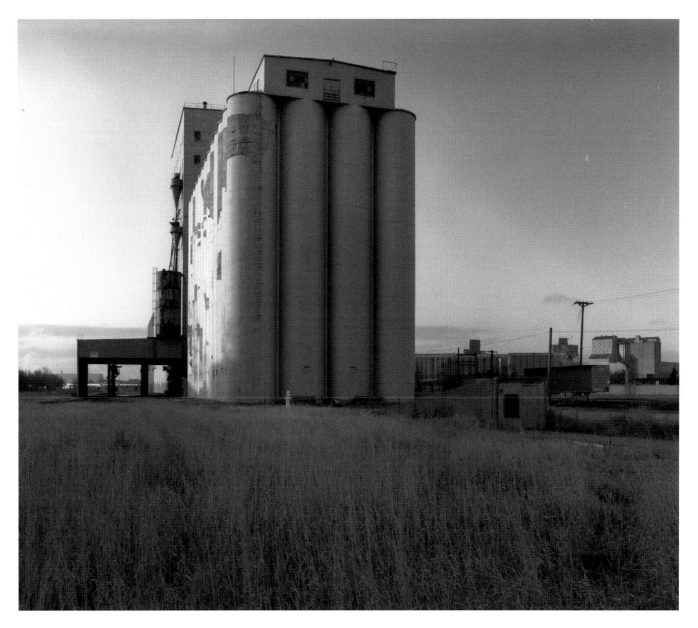

ABANDONED ELEVATOR, KASOTA AVENUE SOUTHEAST, MINNEAPOLIS, 1991

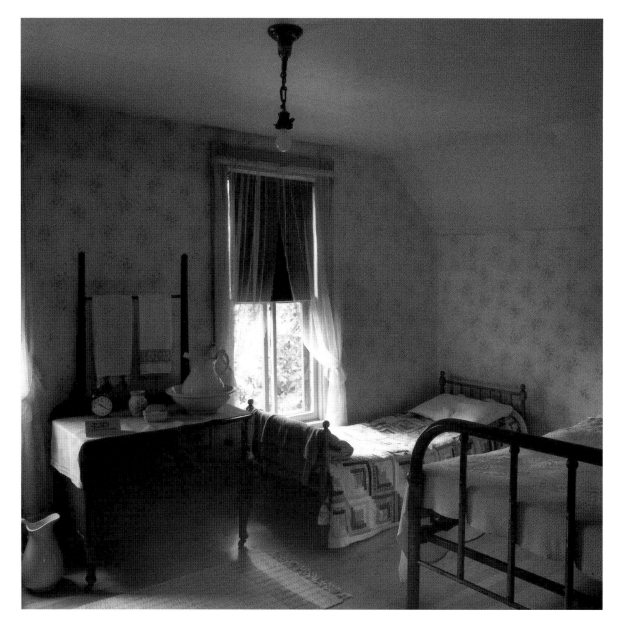

SINCLAIR LEWIS BOYHOOD BED, SINCLAIR LEWIS HOUSE, SAUK CENTRE, MINNESOTA, 1998

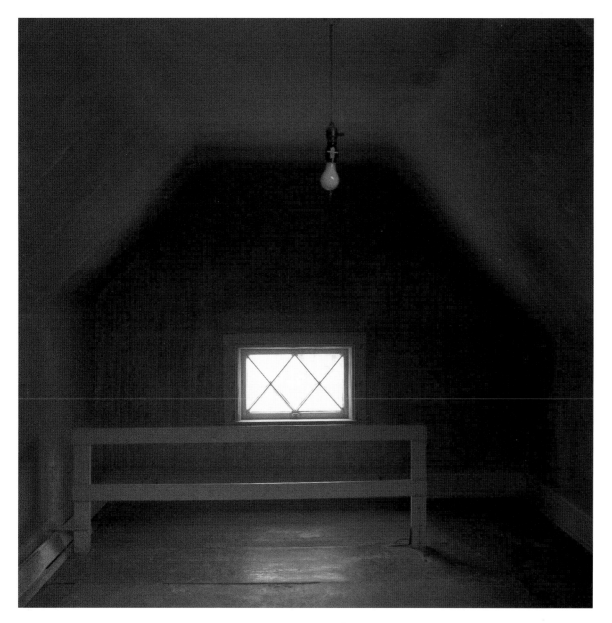

MALZIMMER ATTIC STUDIO, WANDA GÁG HOUSE, NEW ULM, MINNESOTA, 1994

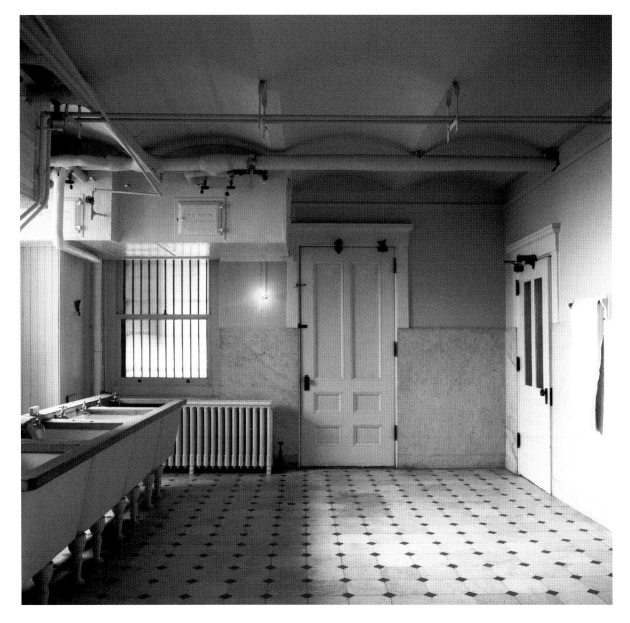

LAUNDRY, JAMES J. HILL HOUSE, ST. PAUL, 1992

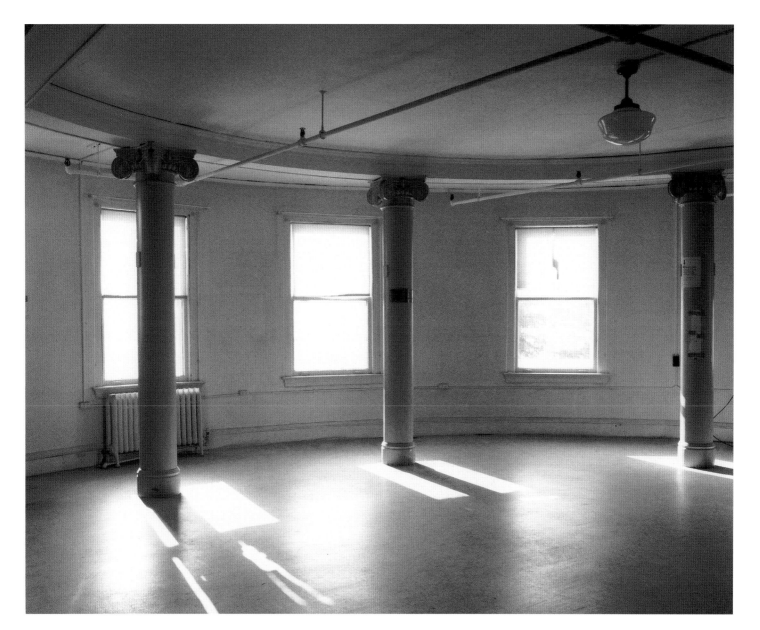

DOMICILIARY, BUILDING NUMBER 6, MINNESOTA VETERANS HOME, MINNEAPOLIS, 1992

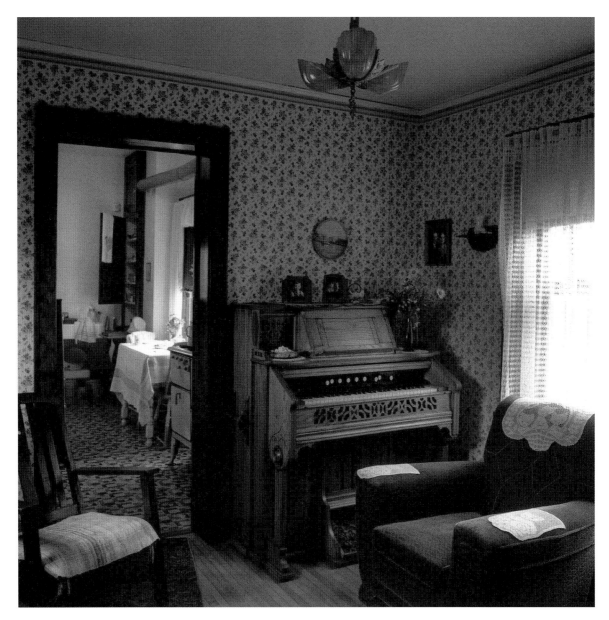

AKERLUND'S APARTMENT ADJACENT TO THE AKERLUND PHOTO STUDIO, COKATO, MINNESOTA, 1996

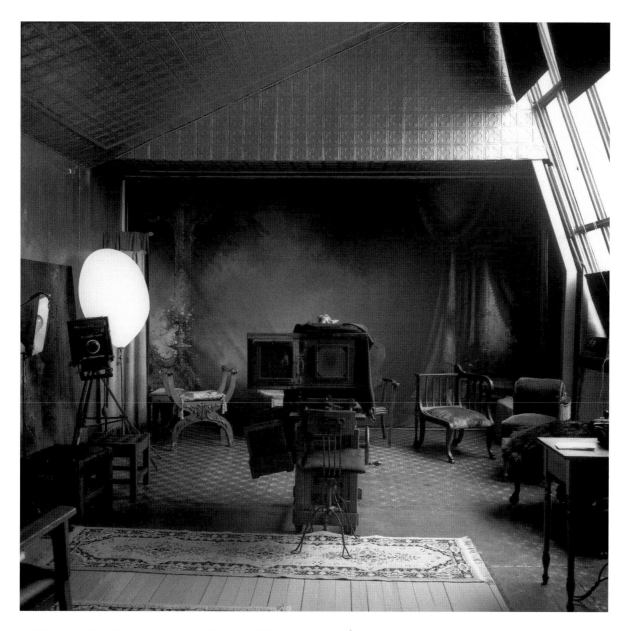

AKERLUND PHOTO STUDIO, COKATO, MINNESOTA, 1996

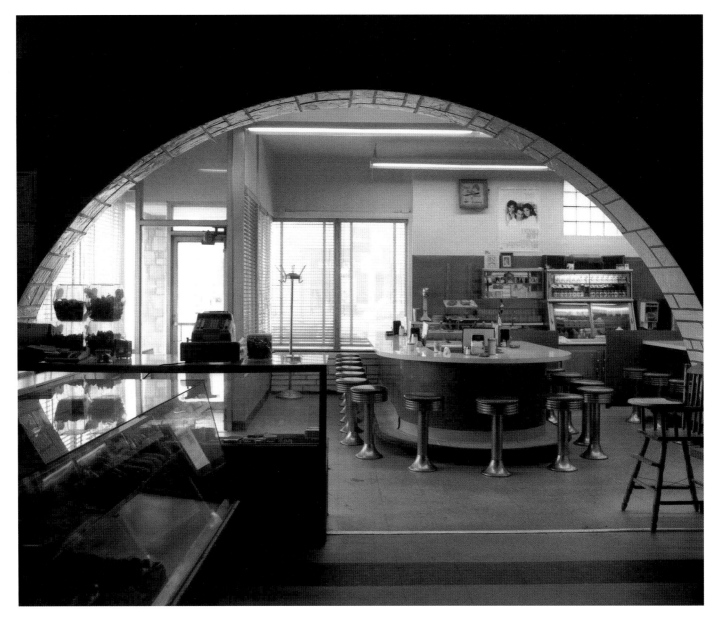

JIM'S COFFEE SHOP AND BAKERY, CENTRAL AVENUE SOUTHEAST, MINNEAPOLIS, 1995

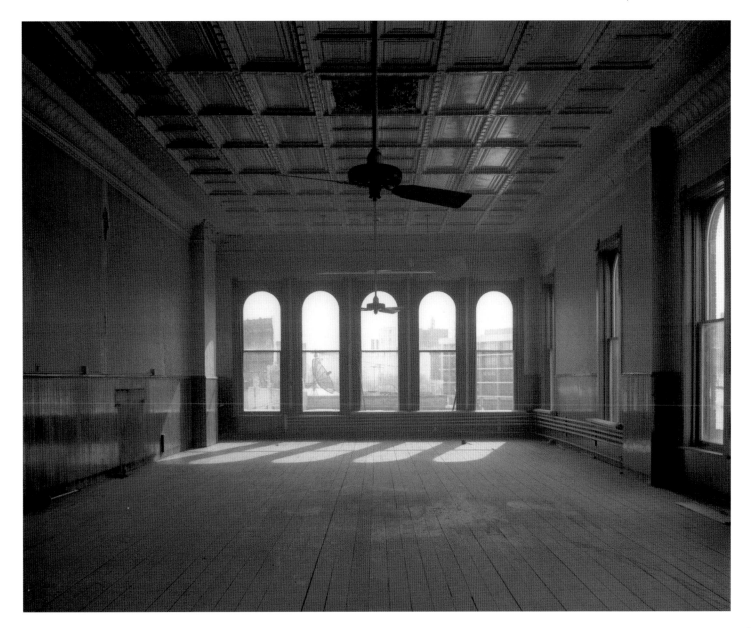

DINING HALL, THIRD FLOOR OF I.O.O.F. BUILDING, EAST HENNEPIN AVENUE AND FOURTH STREET NORTHEAST, MINNEAPOLIS, 1999

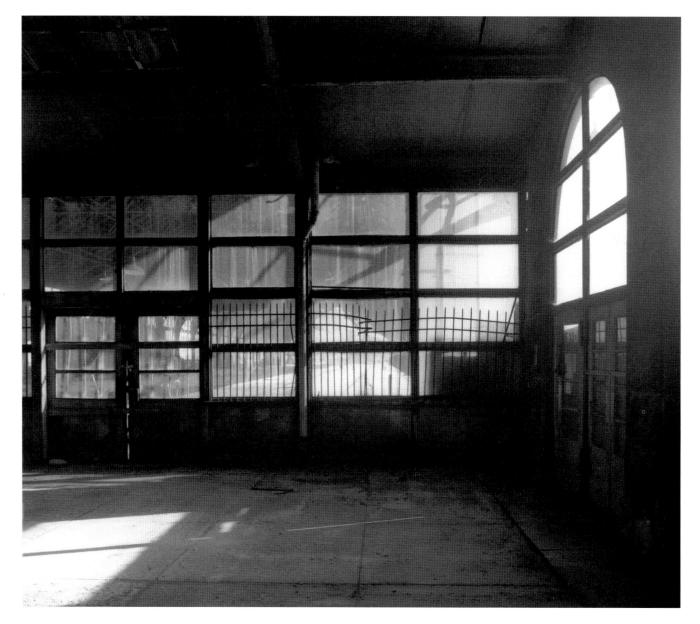

MILWAUKEE ROAD DEPOT, MINNEAPOLIS, 1994

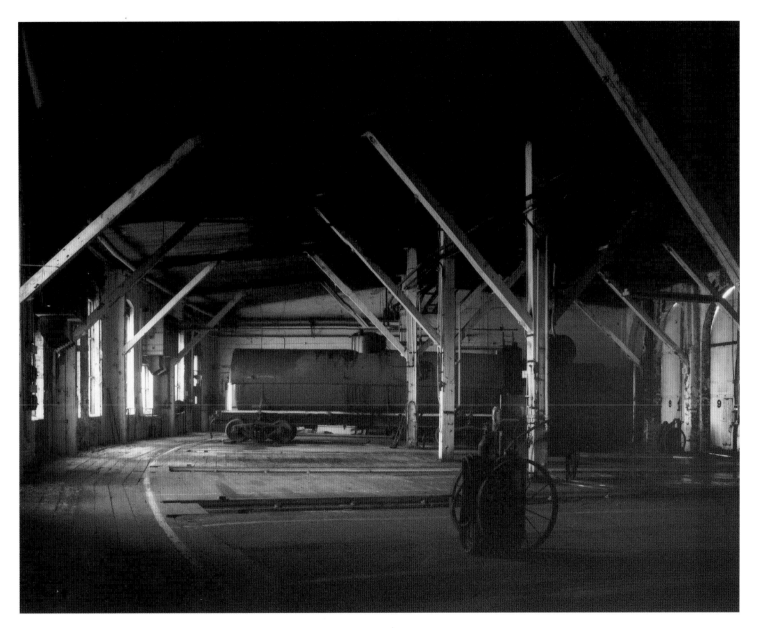

ROUNDHOUSE, SOO LINE SHOREHAM YARDS, NORTHEAST MINNEAPOLIS, 1998

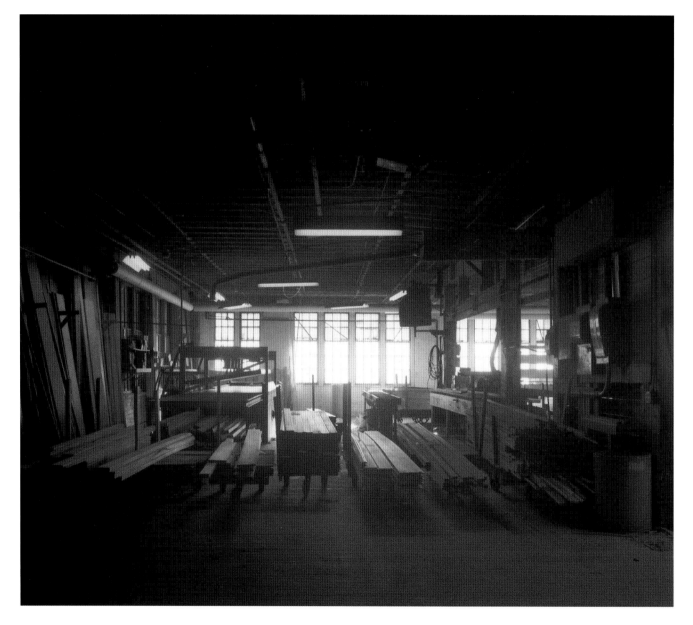

AARON CARLSON WOODWORK, CENTRAL AVENUE NORTHEAST, MINNEAPOLIS, 2002

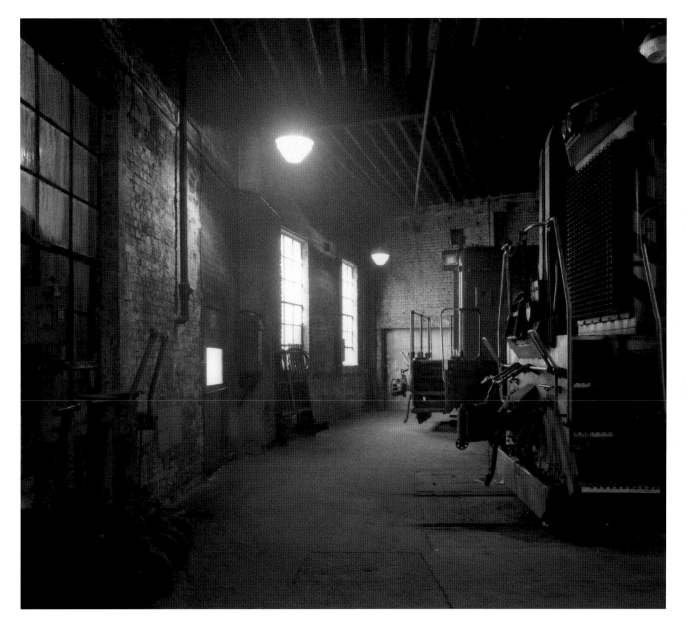

ROUNDHOUSE, MINNESOTA TRANSFER RAILWAY COMPANY, CLEVELAND AVENUE NORTH, ST. PAUL, 1994

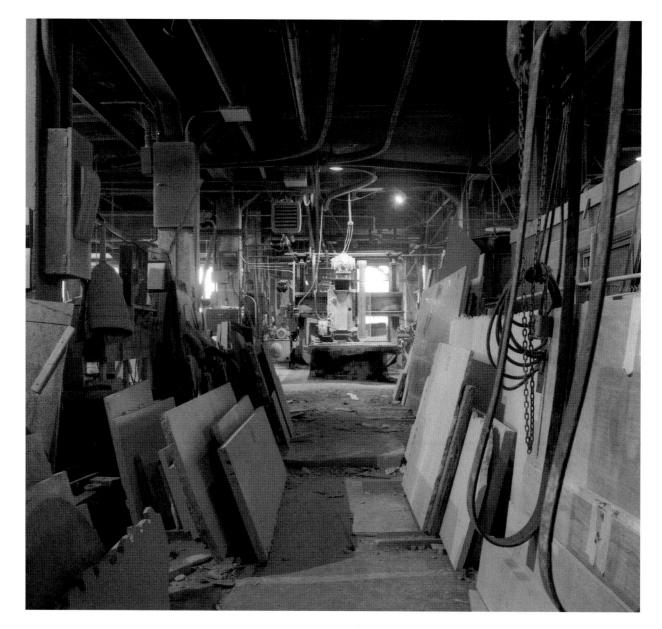

DRAKE MARBLE COMPANY, PLATO BOULEVARD, ST. PAUL, 1995

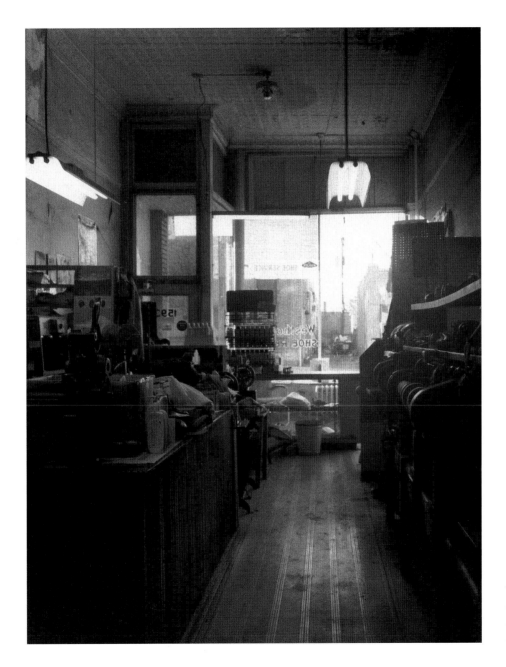

WESTHOLTER
SHOE REPAIR,
SELBY AVENUE,
ST. PAUL, 1994

[61

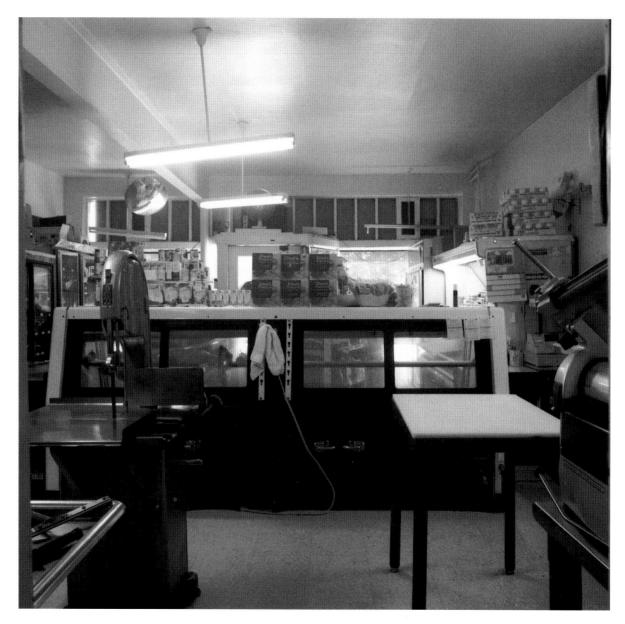

L'CHAIM KOSHER MEAT MARKET AND DELI, RANDOLPH AVENUE, ST. PAUL, 1998

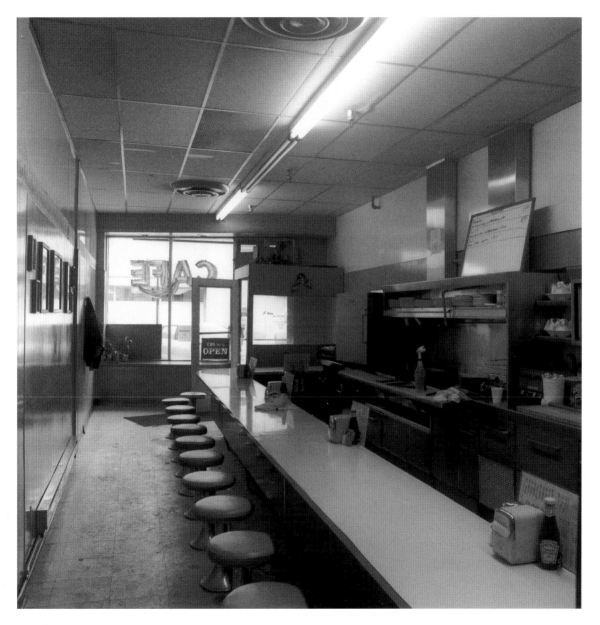

JIM'S HAMBURGERS, SEAWAY HOTEL, WEST SUPERIOR STREET, DULUTH, 2002

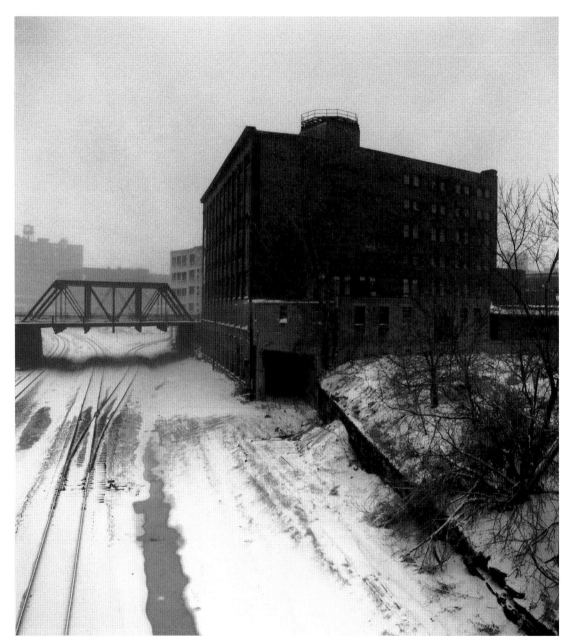

ROCK ISLAND BUILDING
AND BURLINGTON
NORTHERN TRACKS,
WASHINGTON AVENUE
NORTH, WAREHOUSE
DISTRICT, MINNEAPOLIS,
1992

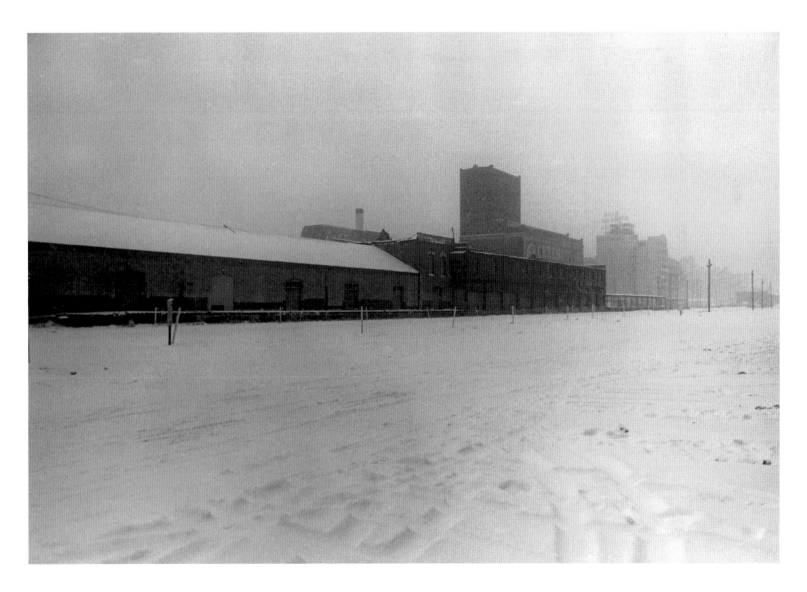

MILWAUKEE ROAD FREIGHT HOUSE AND CERESOTA ELEVATOR, WEST SIDE MILLING DISTRICT, MINNEAPOLIS, 1988

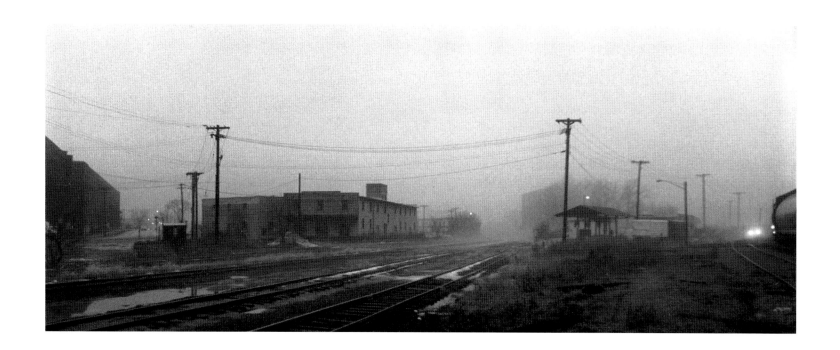

BURLINGTON NORTHERN TRACKS, FOURTH STREET SOUTHEAST, MINNEAPOLIS, 1985

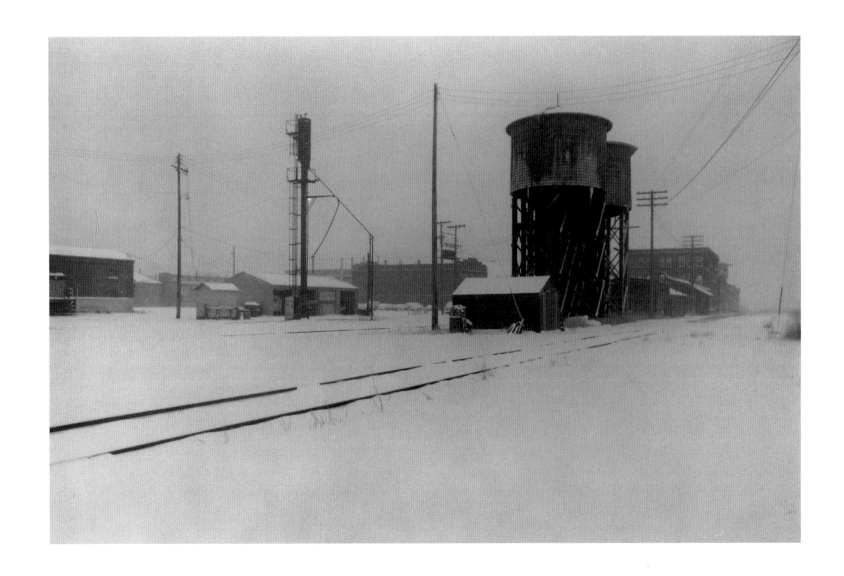

SOO LINE SHOREHAM YARDS, NORTHEAST MINNEAPOLIS, 1988

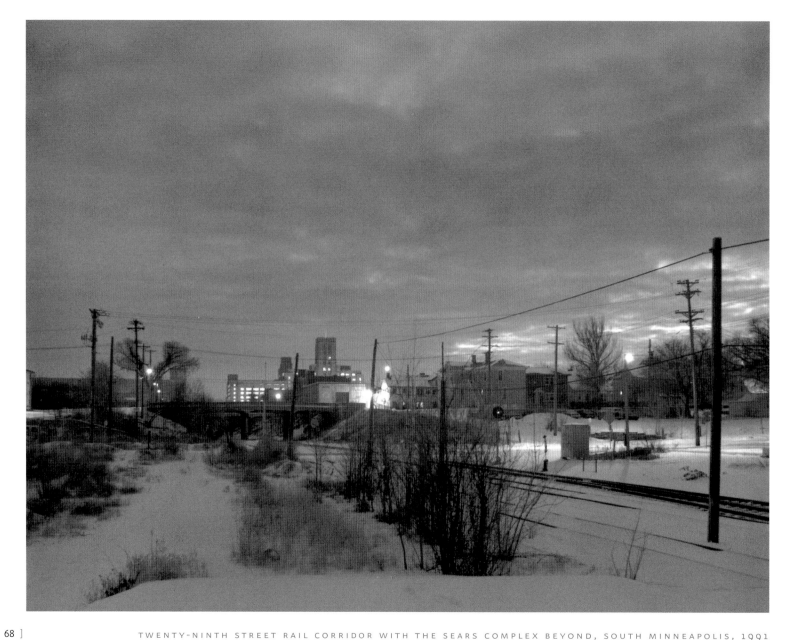

TWENTY-NINTH STREET RAIL CORRIDOR WITH THE SEARS COMPLEX BEYOND, SOUTH MINNEAPOLIS, 1991

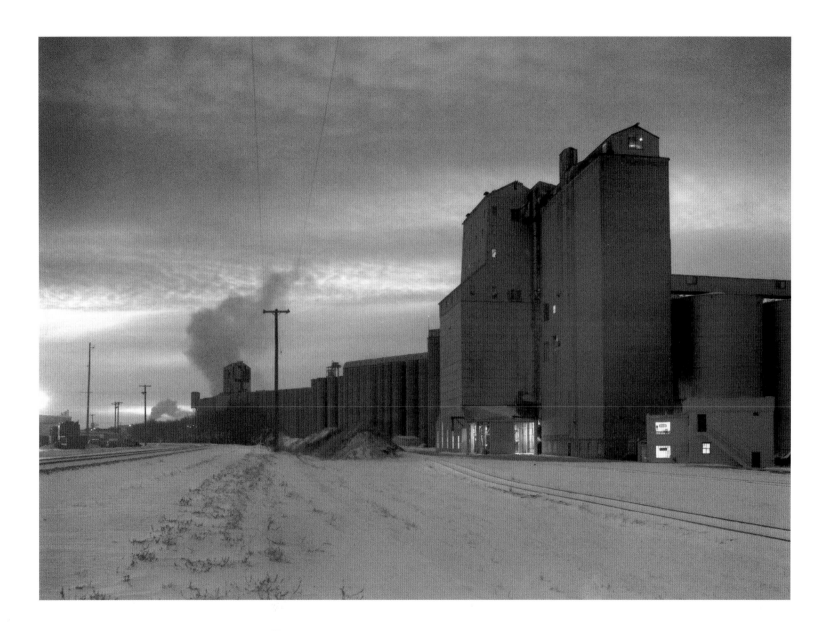

ELECTRIC STEEL ELEVATOR, TWENTY-FIFTH AVENUE SOUTHEAST, MINNEAPOLIS, 1995

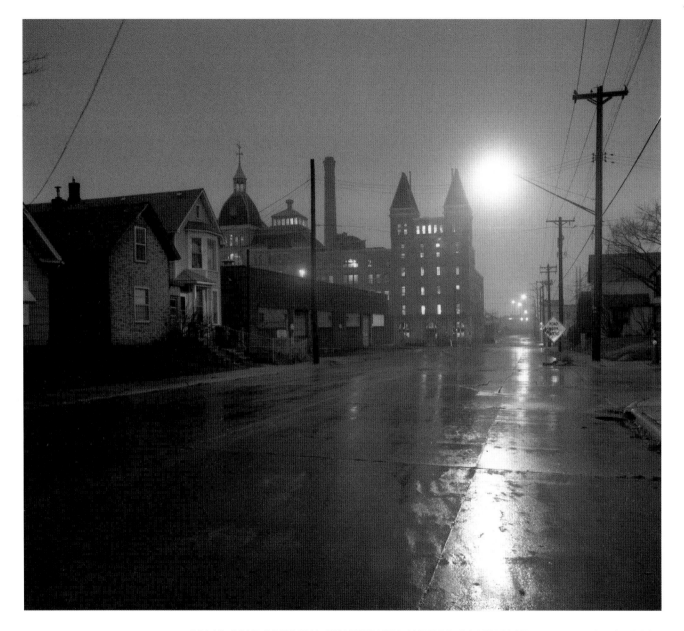

GRAIN BELT BREWERY, THIRTEENTH AVENUE NORTHEAST, MINNEAPOLIS, 2001

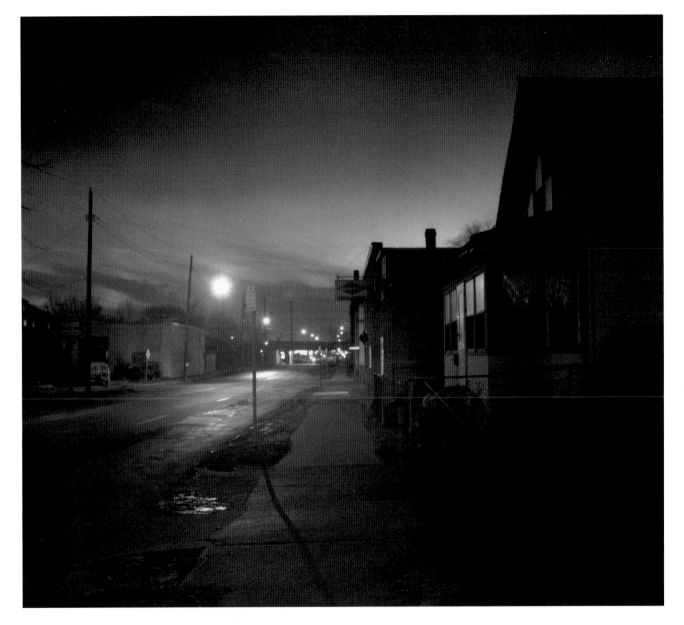

BROADWAY AVENUE NORTHEAST, MINNEAPOLIS, 1993

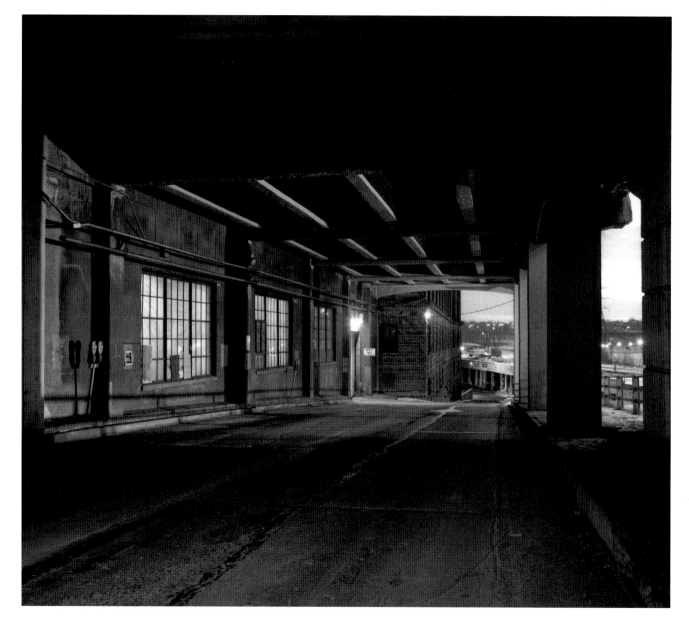

EAST SECOND STREET, ST. PAUL, 1993

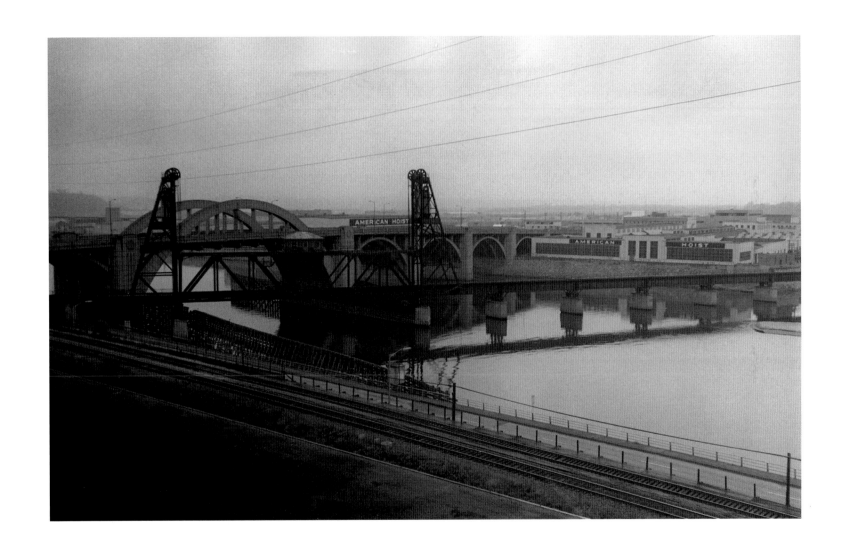

MISSISSIPPI RIVER FROM KELLOGG MALL PARK, ST. PAUL, 1983

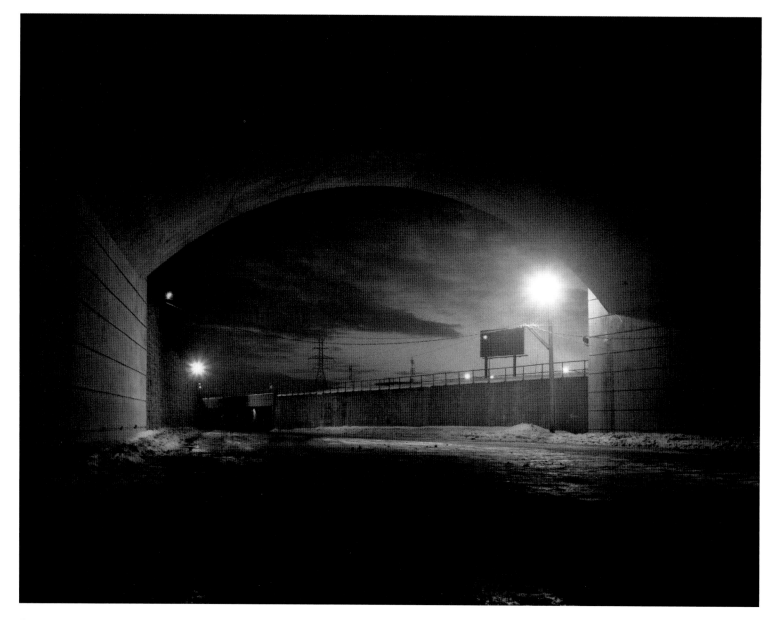

UNDER THE ROBERT STREET BRIDGE, ST. PAUL, 1993

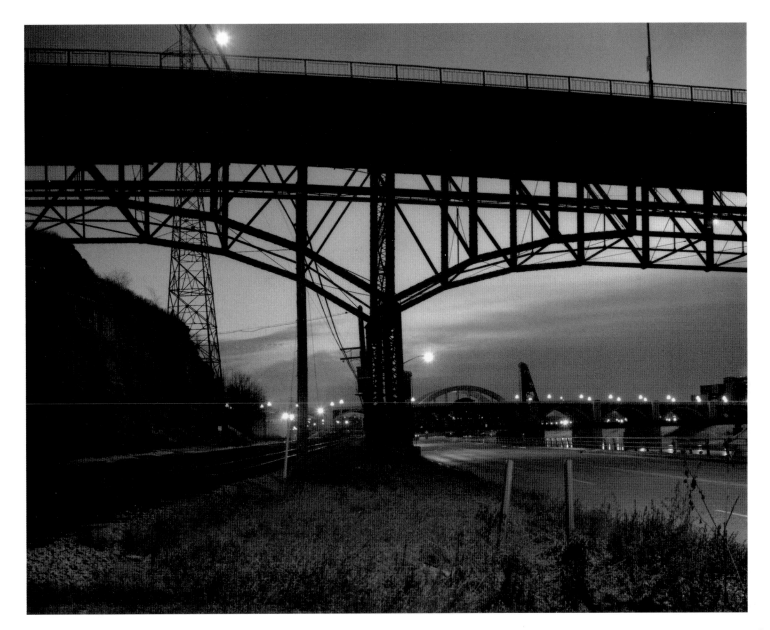

WABASHA AVENUE BRIDGE WITH ROBERT STREET AND LIFT BRIDGE BEYOND, ST. PAUL, 1995

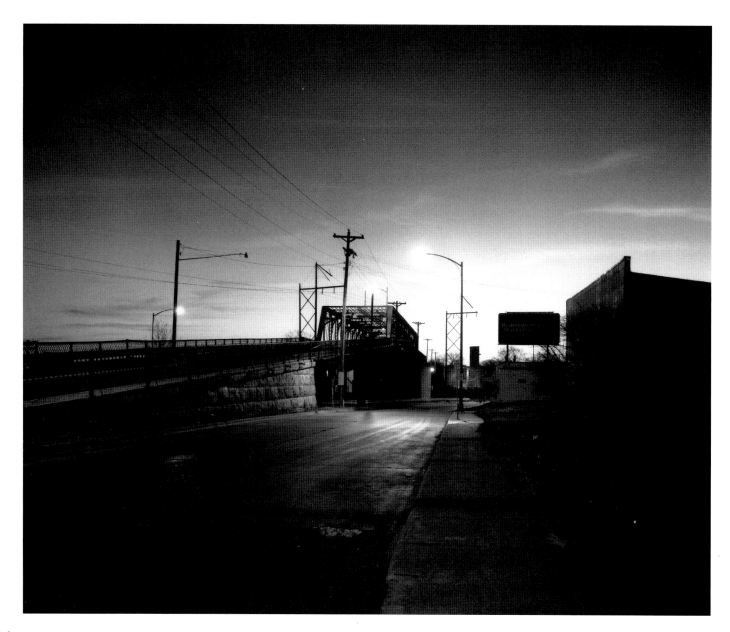

SELBY AVENUE BRIDGE, ST. PAUL, 1990

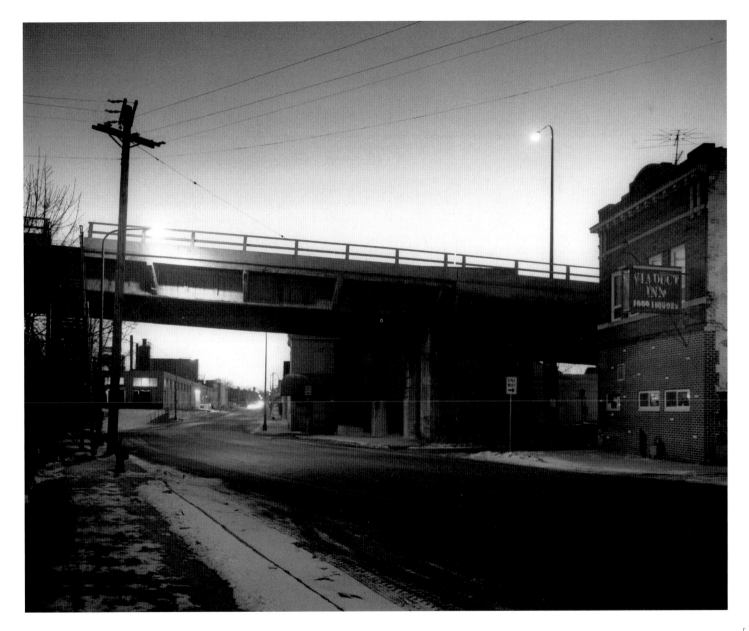

EARL STREET VIADUCT, EAST SEVENTH STREET, ST. PAUL, 2001

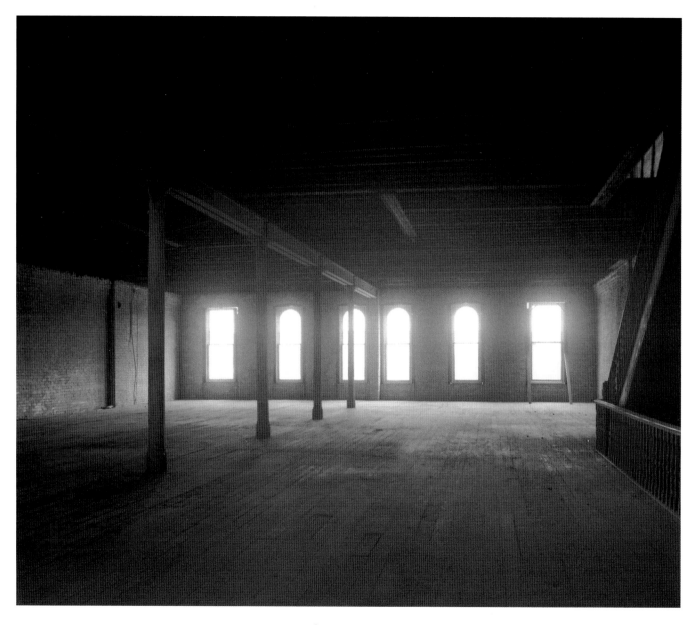

O'CONNOR BUILDING, EAST SEVENTH STREET, ST. PAUL, 2001

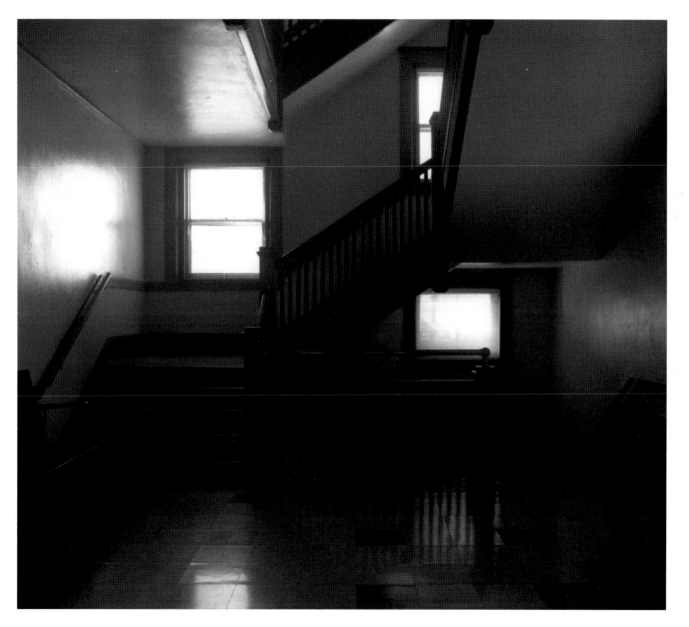

CHARLES THOMPSON MEMORIAL HALL FOR THE DEAF, MARSHALL AVENUE, ST. PAUL, 1994

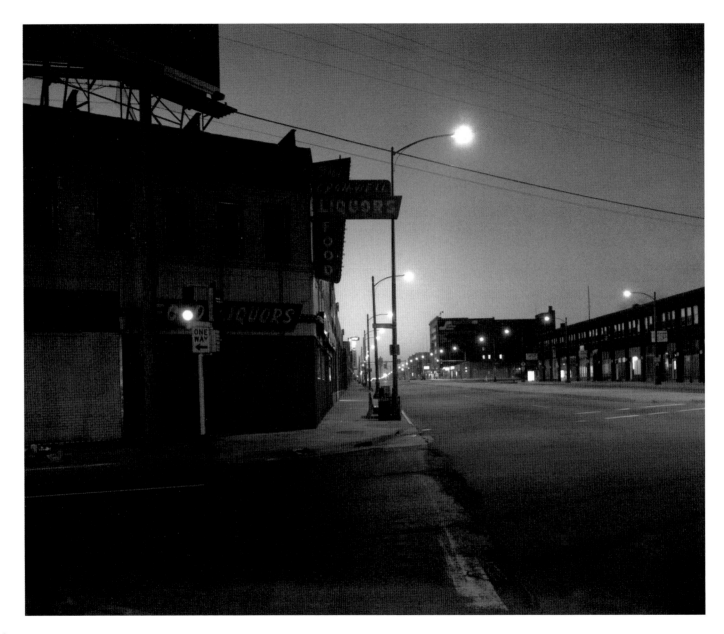

UNIVERSITY AVENUE, ST. PAUL, 1990

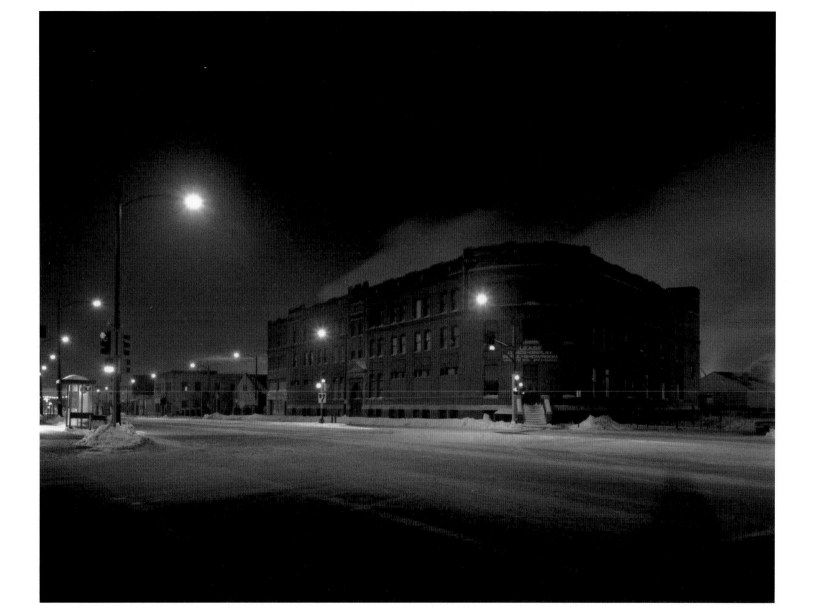

SPECIALTY MANUFACTURING COMPANY, UNIVERSITY AND RAYMOND AVENUES, ST. PAUL, 1994

MIKE MELMAN is an architect and photographer from Minneapolis. His photographs have been exhibited in numerous galleries and museums in the Twin Cities and have been published in *Architecture Minnesota* and *Minnesota History.*

BILL HOLM is a poet and essayist living in Minneota, Minnesota. He teaches at Southwest State University in Marshall, Minnesota, and spends summers at his small house on a fjord in north Iceland. Among his recent books are *Eccentric Islands: Travels Real and Imaginary* and *The Heart Can Be Filled Anywhere on Earth.*